IMAGES
of America

DANNEMORA

To the Poet of Plattsburgh
Tom Braga, I enjoy our
talks.

ON THE COVER: This 1890 photograph by George C. Baldwin shows the keeper's office in the Main Hall cellblock. The office looks like a storefront on a street corner, which gives it an outside world look. (Author's collection.)

IMAGES
of America

DANNEMORA

Rod Bigelow and Walter "Pete" Light

ARCADIA
PUBLISHING

Copyright © 2015 by Rod Bigelow and Walter "Pete" Light
ISBN 978-1-4671-2309-9

Published by Arcadia Publishing
Charleston, South Carolina

Printed in the United States of America

Library of Congress Control Number: 2014949515

For all general information, please contact Arcadia Publishing:
Telephone 843-853-2070
Fax 843-853-0044
E-mail sales@arcadiapublishing.com
For customer service and orders:
Toll-Free 1-888-313-2665

Visit us on the Internet at www.arcadiapublishing.com

Dedicated to Terrance Gilroy and all the families of the town of Dannemora, who, over the years, worked and made history

CONTENTS

ACKNOWLEDGMENTS

Both individuals and institutions must be thanked for their help in putting this book together: Joanne Glasgow, PhD, for editing and advice; Eleanor Mayette, for editing and advice; the Friends of Lyon Mountain Mining and Railroad Museum; Judy Lapoint, Kathleen King, and Don Jackson, Chazy Lake historians and coauthors of *Chazy Lake: Facts, Fiction, and Folklore*; *A Century-Mining for Souls 1875–1975* produced by parishioners; Feinberg Library Special Collections SUNY Plattsburgh; Melissa Peck and the Clinton County Historical Museum; Anastasia and Gloria Pratt, Clinton County historians; Julia Dowd and Dick Lynch, Northern New York American-Canadian Genealogical Society; George C. Baldwin, photographer, Malone, New York; Adirondack Museum at Blue Mountain Lake.

The early photographs by Seneca Ray Stoddard within this book are copies collected by Terrance B. Gilroy, the former Dannemora Village and Clinton Prison historian. He, along with Pete Light, created a museum in the prison and later the Village Museum. The rest of the photographs not otherwise notated came from Pete Light, Village of Dannemora historian and museum curator. Pete has been the main source of photographs and history for this book and is coauthor. A few photographs came from Rod's grandmother, to whom I should have listened more.

INTRODUCTION

DANNEMORA was formed from Beekmantown, Dec 14, 1854. It is the central town upon the w. border of the co. Its surface is mostly a wild, mountainous upland, covered with a sandy soil and light growth of forest trees. Chazy Lake, near the center, 3 1/2 miles long by 1 1/2 wide, discharges its waters E. into Chazy River. Upper Chateaugay Lake, on the w. border, 5 mi. long by 1 1/2 broad, discharges its waters w. into Chateauguay River. The few settlements in town are confined to the S.E. corner. Dannemora is a small village grown up around the Clinton Prison. The prison was located here in 1845, for the purpose of employing convicts in the mining and manufacture of iron, so that their labor would not come so directly in competition with the other mechanical trades. The first permanent settler was Thomas Hooker, who came to reside in 1838. The census reports one religious society (Presbyterian) in town.

—French's *Gazetteer of the State of New York*, 1860

The paragraph above from French's *Gazetteer* is a good start on the beginnings of Dannemora. Before the arrival of the Hookers, there was only the occasional hunter or those in search of iron ore. Iron ore was discovered around Chateaugay Lake around 1831, and in 1832 a partnership of 10 area businessman was formed to mine the ore. In 1842, two of the partners, Charles Averill and F.L.C. Sailly, bought out the other eight. For a time, the Averill Ore Bed became a successful mine and provided employment for the surrounding area, including what is now the town of Dannemora.

Most of the land was owned by St. John B.L. Skinner, a lawyer in Plattsburgh who gave the name Dannemora to the western area that was separated from Beekmantown. The name came from a famous Swedish iron ore field that lies northwest of Stockholm, Sweden. The ore fields there were well known since the mid-15th century in Europe, because of the high grade of iron ore. The name Dannemora is a combination of two words: *Danne* derives from the name given to the early settlers in Sweden who were from Denmark—hence the name *Dannes*, or *Danes*, as they are called today. *Mora* describes the fenny spruce tree found in Sweden.

The history of the village of Dannemora is intertwined with the development of Clinton prison. In 1816, New York followed the lead of other states and passed a law providing for two prisons. Auburn Prison and Sing Sing (Mount Pleasant) were built in the following decade. Both prisons were meant to be self-supporting, Auburn with its workshops and Sing Sing with its marble quarries.

The need for a third prison in New York State became evident by the late 1830s. This time, the state legislature specified that mining and smelting of metal ore by convict labor would be permitted. This would help satisfy the complex political demands and limit the effect on private enterprise. The year was 1842, and Ransom Cook of Saratoga was appointed commissioner to

examine mineral resources in the state and obtain proposals for the purchase of iron mines. He was also to study the possibility of using inmate labor in the mining of iron ore and smelting.

In 1843, Ransom Cook reported, "These are the best located mines of any I have visited." On May 13, 1844, the legislature approved a new state prison, located north of Albany and named after the county where it would be located. Thus, the name Clinton Prison was created. It was also designated to use the prison convicts in mining and manufacturing of iron.

Silas Cook was confirmed in 1845 as the agent at the state's new prison. Many local men were hired for the clearing of the land in February in the midst of five feet of snow. They had to clear the virgin timber and erect a stockade. Work on the temporary buildings for the officers, guards, workmen, and prisoners was started by April 21, 1846. There was still some three feet of snow on the ground when construction of various structures, including a kiln for drying lumber, carpenter shop, kitchen, guardroom, blacksmith shop, physician's office, tailor, shoe shop, and clerk's office was begun for the incoming inmates. The late-spring road conditions and other inconveniences in erecting these buildings put the completion time back to June of that year.

On June 3, 1845, the villagers stood in amazement as the striped black and white uniforms of the incoming draft of convicts marched from Plattsburgh to the main gate. Each had his attached ball and chain, which was also an unusual sight. The contingent of 50 men came from Mount Pleasant Prison, and to them the sight of the area must have been bewildering. Each one was probably wondering about his crime and if it was worth being sent to this forsaken spot in the Adirondacks. Construction progress was slow, as the heavy chains hindered the men's movements. It was soon decided to lighten the chains, and productivity increased.

About this time, Gov. William Bouck made an inspection of the facility. He had traveled from Keeseville to Cadyville after his train ride from Albany. The journey from Cadyville was all on foot, and the governor must have been in excellent shape to climb the hills. From that time to the present, many changes and events have occurred. Later chapters will cover the growth of the area and explore the unique aspects of Clinton Prison as well as the construction and growth of the prison, state hospital, and village. The prison riot of 1929, the North Yard and its "courts" and ski jump, and the building of St. Dismas Church inside the walls of the prison are all interesting sections of this book. There were mining accidents, drownings at Chazy Lake, and executions by electric chair. These are all part of the history of the prison, as well as famous and infamous visitors. Lucky Luciano, Joe Valachi, "Son of Sam," and Tupac Shakur were just some of the incarcerated. The more well-known visitors included Jack Dempsey and Jersey Joe Walcott to visit and meet with the prisoners. Clark Gable and other movie stars stayed at Chazy Lake, as well as opera personalities visiting Reinald Werrenrath, a prominent baritone and teacher of his day. Chazy Lake was a summer haven for his family, his students, and his many prominent guests. Eleanor Roosevelt spent time at Werrenrath's "Shanty" on two occasions, and Gov. Franklin Roosevelt visited Dannemora to inspect the facilities. Chazy Lake, Lyon Mountain, Upper Chateaugay Lake, and the village of Dannemora compose the area known as the town of Dannemora. The last two chapters are limited and may be dealt with in further publications. The last caption on Stoddard photographs gives a thank-you to this wonderful photographer. He captured the early days in the Adirondacks.

One

THE EARLY SETTLEMENTS

Pictured here is Lydia Hooker's cemetery stone. Lydia and Phineas Hooker arrived in 1836 to house the miners who were coming to the area. According to Hurd's 1880 *History of Clinton County*, Lydia Hooker claimed to be the first woman to live in the area later to be named Dannemora. The Hookers spent their early days living in a log shack, and Lydia "cooked the meal of victuals on the hill." The Hookers are buried in a small lot adjacent to the northeast corner of St. Joseph's Cemetery.

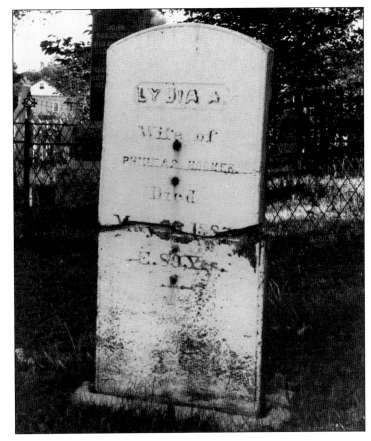

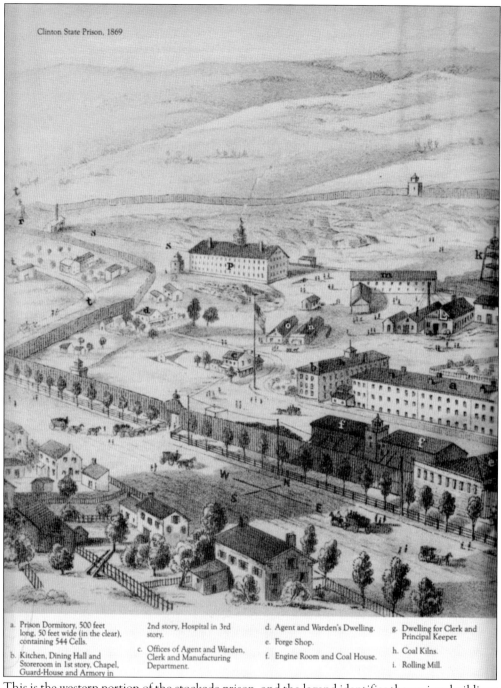

Clinton State Prison, 1869

a. Prison Dormitory, 500 feet
 long, 50 feet wide (in the clear),
 containing 544 Cells.

b. Kitchen, Dining Hall and
 Storeroom in 1st story, Chapel,
 Guard-House and Armory in

2nd story, Hospital in 3rd
story.

c. Offices of Agent and Warden,
 Clerk and Manufacturing
 Department.

d. Agent and Warden's Dwelling.

e. Forge Shop.

f. Engine Room and Coal House.

g. Dwelling for Clerk and
 Principal Keeper.

h. Coal Kilns.

i. Rolling Mill.

This is the western portion of the stockade prison, and the legend identifies the various buildings
and areas.

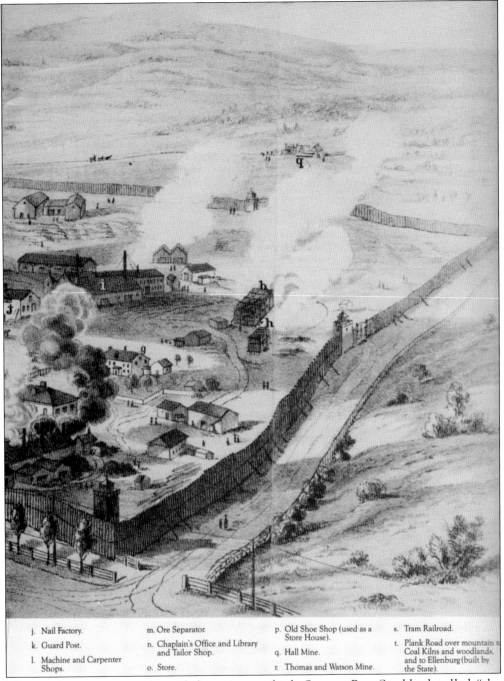

j. Nail Factory.	m. Ore Separator.	p. Old Shoe Shop (used as a Store House).	s. Tram Railroad.
k. Guard Post.	n. Chaplain's Office and Library and Tailor Shop.	q. Hall Mine.	t. Plank Road over mountain to Coal Kilns and woodlands, and to Ellenburg (built by the State).
l. Machine and Carpenter Shops.	o. Store.	r. Thomas and Watson Mine.	

This is the eastern portion of the prison, which Seneca Ray Stoddard called "the Wilderness Prison."

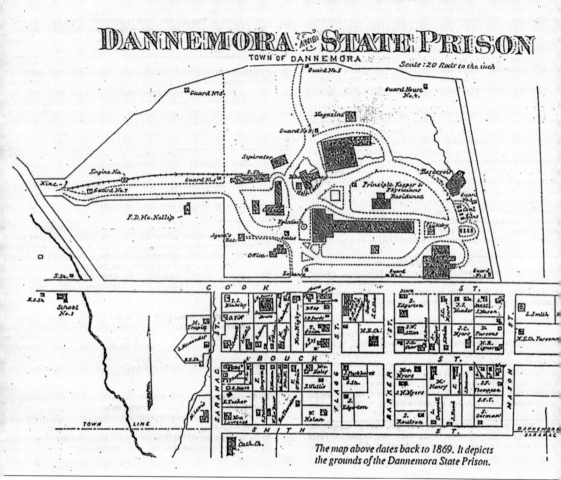

The map above dates back to 1869. It depicts the grounds of the Dannemora State Prison.

This 1869 map depicts the village of Dannemora and the adjoining prison. "Enclosing the prison, perhaps a mile in circuit, was a wooden fence 20 feet high, braced on the east not as one would expect, from the inside, but from the outside . . . At various intervals along the fence were nine little houses on stilts above the fence, with balconies. They were reached by stairways through trap doors in the floor. Men with repeating rifles persuaded convicts away from the fence." (Stoddard.)

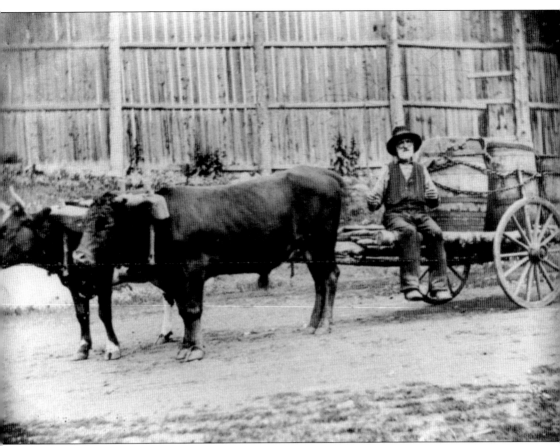

Pictured here in 1880 is Moses Goodrich. No doubt Goodrich and his ox cart were a familiar sight about Dannemora, as he sold water to both the prison and villagers. In the background looms the wooden stockade that originally surrounded the prison grounds. Between 1881 and 1887, this stockade was replaced by stone walls at a cost of $20,000. (Stoddard.)

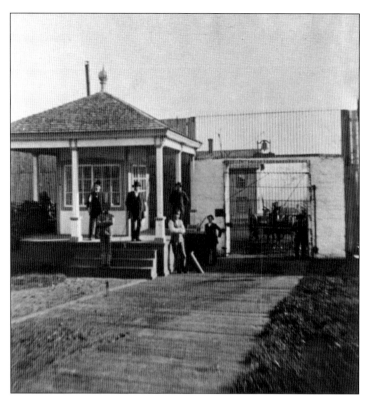

This is a view from inside the front gate looking south to Cook Street. (Stoddard.)

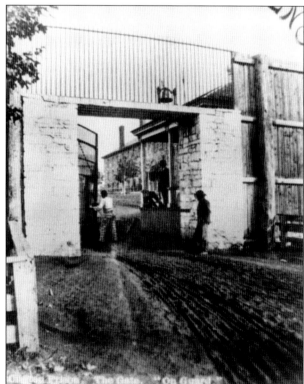

Note the stockade wall in this view from outside the front gate. The walls were 20 feet high, and one could hardly fit a pin between the joints. (Stoddard.)

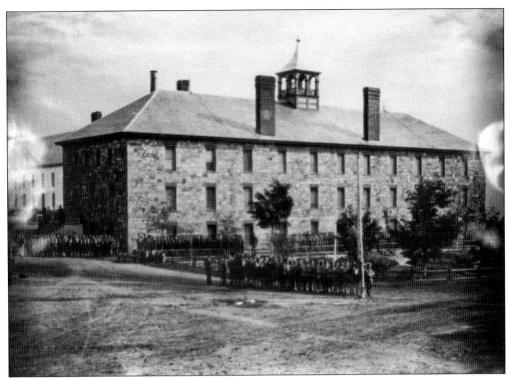

Stoddard took this photograph of the main building in 1875. This three-story structure contained the mess hall, kitchen, guardroom, and offices. The building behind is the first cellblock. The main building was destroyed by fire in 1890. (Stoddard.)

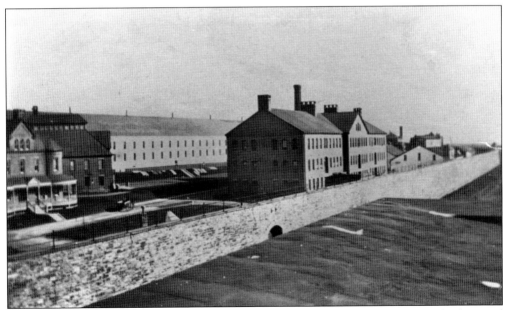

The building just behind the wall contains the engine room and coal house. In the background is the first cellblock. (Stoddard.)

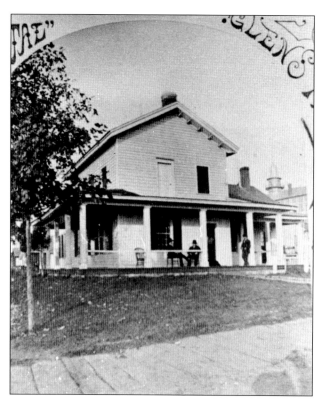

Pictured here are the offices of the agent, warden, and clerk, as well as the manufacturing department. (Stoddard.)

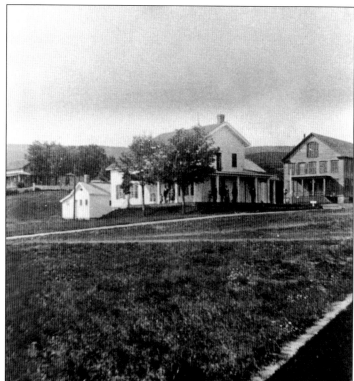

This is another view of principal keeper's (PK) office. The PK was the inside supervisor, second only to the warden. The warden was a political appointee, while the principal keeper was promoted from within the ranks. (Stoddard.)

Pictured here is the Post Five guard tower within the stockade wall. Note the shanty below on the left. (Stoddard.)

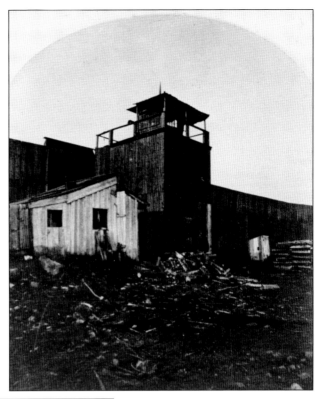

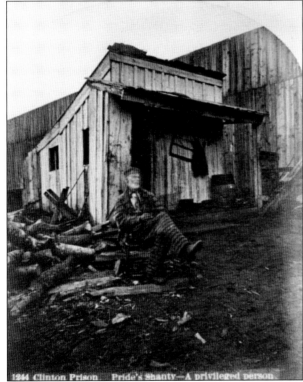

1244 Clinton Prison Pride's Shanty—A privileged person

This early 1870s image shows an elderly, well-behaved prisoner and his shanty just inside the wooden stockade. "Pride's Shanty" was a privilege earned by good behavior. Other prisoners may have received this treatment, but no record exists. (Stoddard.)

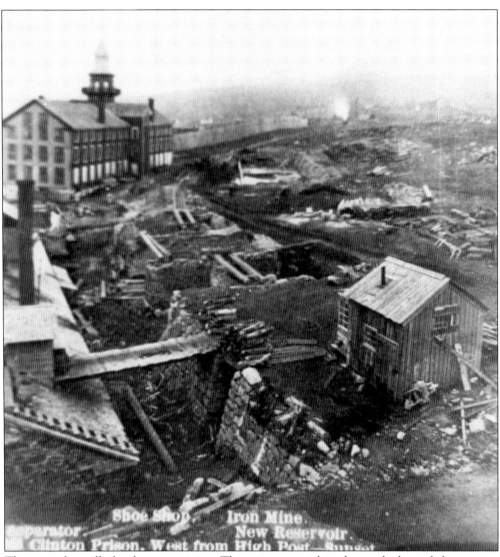

Shoe Shop. Iron Mine.
Separator. New Reservoir.
Clinton Prison. West from High Post—Sunset

These are the mills for the iron mining. The mine was within the stockade, and the ore was mined and sent by tram to the mills. Ransom Cook was an inventor and innovator, and the iron-producing machinery was described by a local businessman as far superior to anything of its kind. Cook designed the original equipment constructed for elevating, crushing, winnowing, and separating the ore. (Stoddard.)

From this vantage point, the agent and warden's office is in the distance with the gate further south. On the right side of the foreground is the laundry, with the machine and carpenter shops on the left. (Stoddard.)

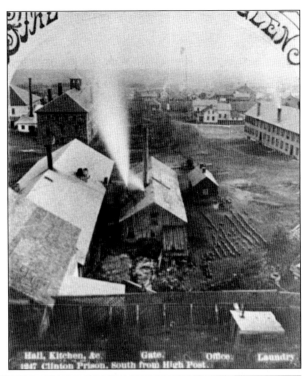

Hall, Kitchen, &c Gate. Office. Laundry
1847 Clinton Prison. South from High Post.

The mine was located near the corner of Fairbanks Avenue and present-day North Emmons Street. This is the only known photograph of the early Fairbanks Mine. Remnants of the old stockade can still be found in the area. (Stoddard.)

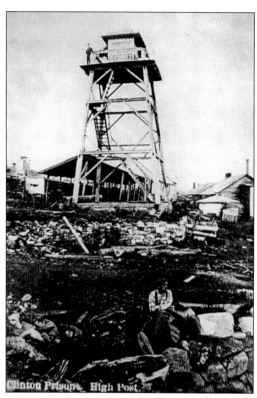

Pictured here is the high post tower, from which Stoddard took quite a few photographs. He made two visits to Dannemora, once in the early 1870s and again in the 1880s. (Stoddard.)

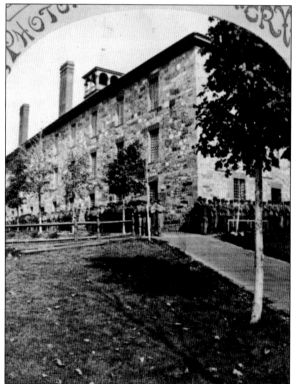

These convicts are lined up outside the main building around 1875, ready to march off in lockstep (with hands on the shoulders of the individual in front). (Stoddard.)

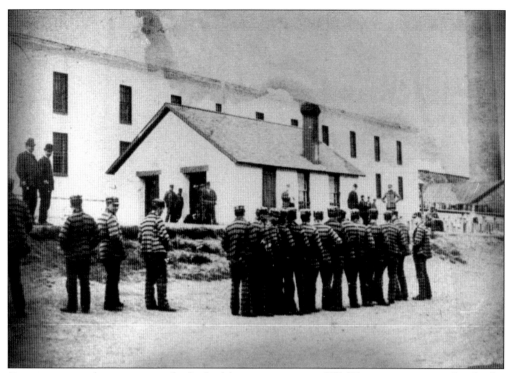

Convicts await their turn outside the bathhouse in groups of 50. They were permitted to bathe once every two weeks. (Stoddard.)

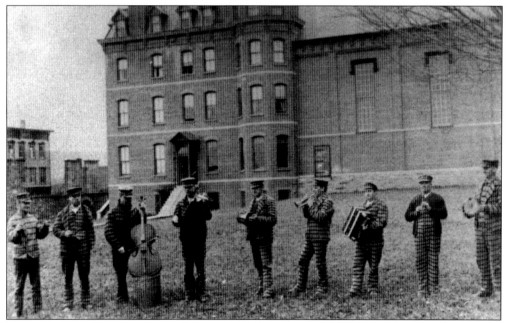

The convict band poses in front of the newly built warden's residence and South Hall. Note the striped uniform worn into the 1870s. (Stoddard.)

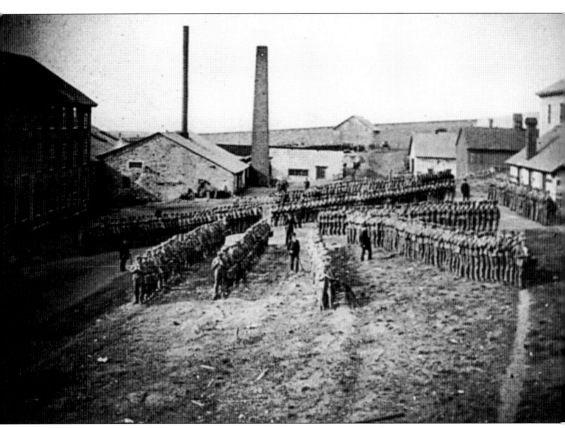

This photograph depicts the lockstep, which was used to limit inmates' mobility in the 1880s. Stoddard described the procession as "a ringed and striped mass, like a huge worm surprised at the sunshine, squirms and twists down the hillside." (Stoddard.)

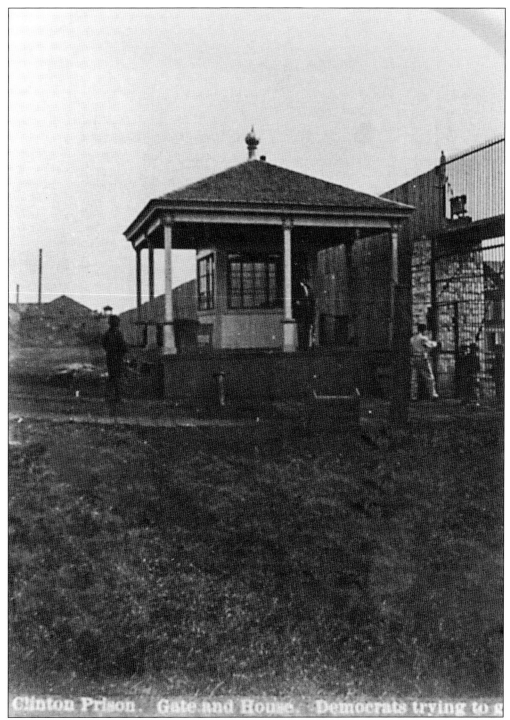

Clinton Prison. Gate and House. Democrats trying to s

This is another view of the gatehouse from inside the prison walls. A force of 50 men was employed at one time, consisting of the warden, principal keeper, sergeant of the guard, 28 guardsmen, and 19 regular keepers. Also, a clerk, physician, chaplain, yard keeper, kitchen keeper, teachers, and foremen were employed by the prison. (Stoddard.)

Pictured here is the striped jacket worn by convicts into the 1880s.

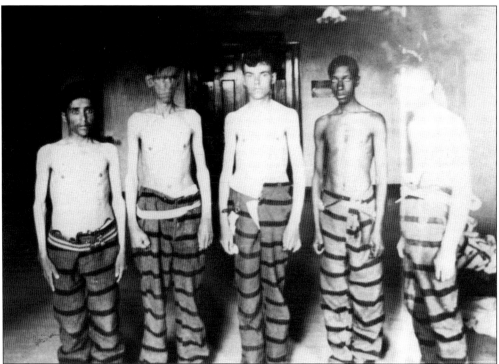

Five convicts wearing striped pants pose uncomfortably for this photograph. The striped uniforms were gradually phased out, and the first-year convicts wore the striped pants.

This is another view of Main Hall. The keeper's office was at the end of the main cell hall. (Stoddard.)

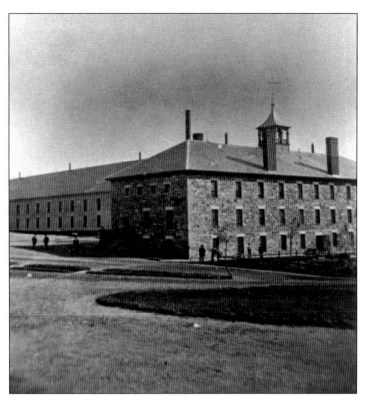

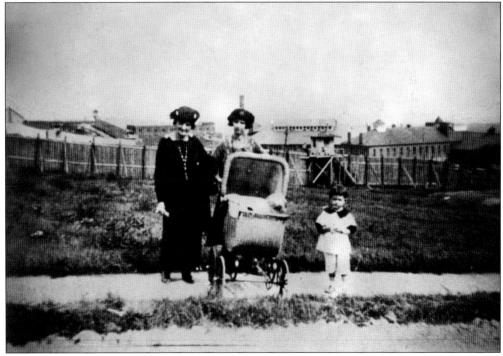

Pictured here are three generations of the Corrigan family with the stockade fence in the background. This image was captured of the west wall, along what is now North Emmons Street.

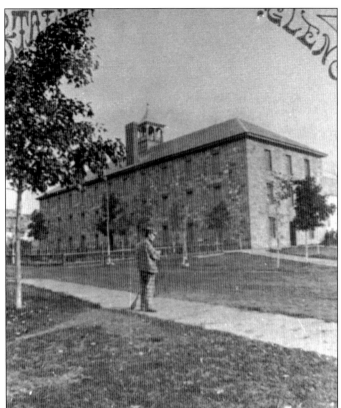

A convict stands idly with a broom in front of an early main building that housed the mess hall, kitchen, guardroom, armory, and chapel. The hospital was on the third floor. (Stoddard.)

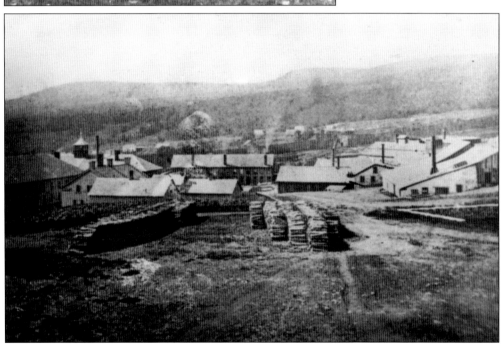

Looking west toward Dannemora and the Johnson Mountains, one can barely make out the stockade wall still standing. Machine and carpenter shops are also visible. (Stoddard.)

In this early view of the prison, a wagon passes by the first cellblock and Main Hall carrying a load of charcoal headed for the iron ore forge. (Stoddard.)

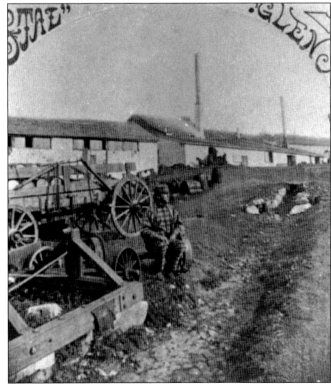

A lone convict looks off into the distance in front of the machine shop, rolling mill, and carpenter shop. (Stoddard.)

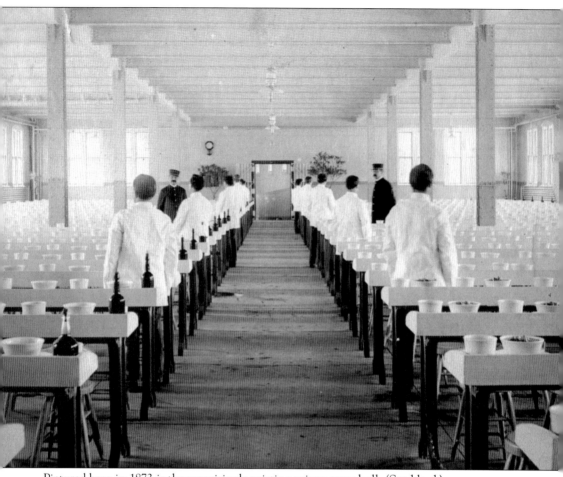

Pictured here in 1873 is the surprisingly pristine prison mess hall. (Stoddard.)

The interior of East Hall cellblock was partially finished in 1845 and completed in 1880. It had 656 new cells, and many cells stayed empty until 1887 due to low population. They were filled by 1893, when the prison population surpassed 1,000 for first time. (Stoddard.)

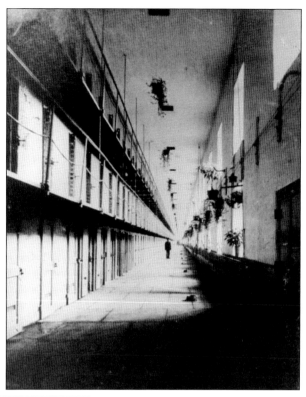

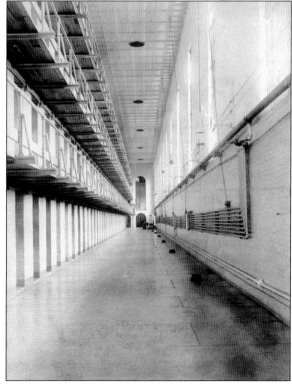

The West Hall cellblock was completed in 1880 and joined the South Hall at a right angle. (Stoddard.)

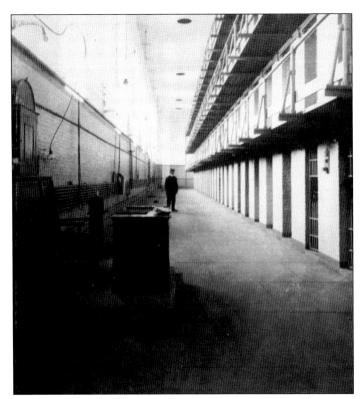

The South Hall cellblock joined the West Hall and the back end of the new warden's residence. (Stoddard.)

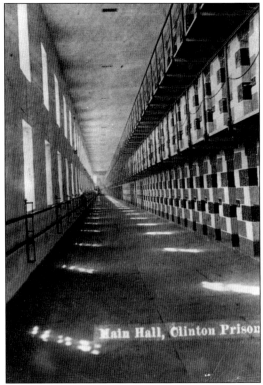

Compare this 1876 image of the original cellblock to the newer East, West, and South Halls. (Stoddard.)

A horse-drawn sledge glides through the gate in the dead of winter. (Stoddard.)

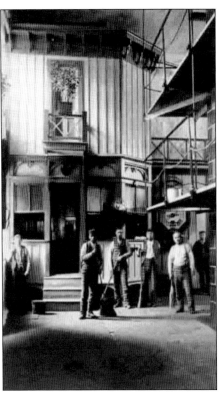

This Baldwin photograph taken in 1890 shows convicts on a cleaning detail in front of the keeper's office. (1890 Baldwin.)

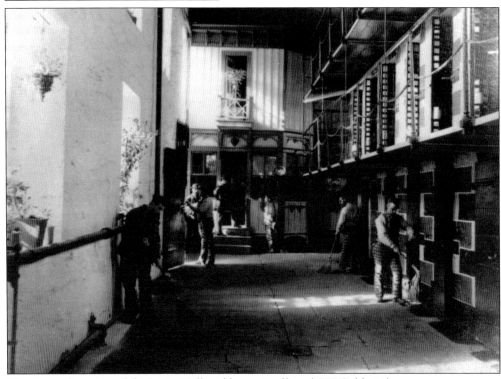

This is another view of the Main Hall and keeper's office. (1890 Baldwin.)

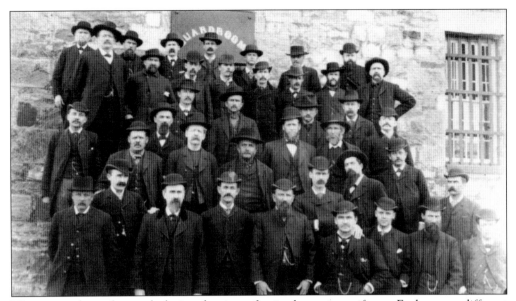

These were the early guards during the time of striped convict uniforms. Each wore a different hat, mostly derbies. (1890 Baldwin.)

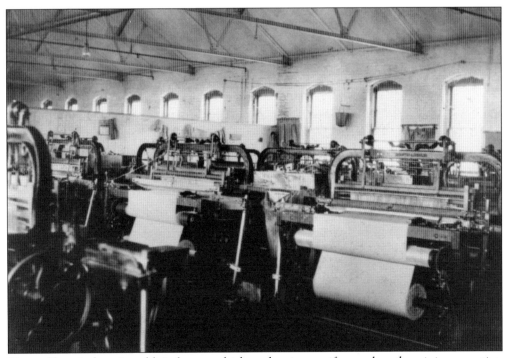

Pictured here is the prison fabric factory, which made prison uniforms when the mining operation stopped for economic and political reasons. Fabric, uniforms, and all other manufactured items were for prison use only. (1890 Baldwin.)

In 1884, construction began on a stone wall around the front of the prison to replace the old stockade. Between 1884 and 1887, this stockade was replaced by stone walls at a cost of $20,000. Moses Goodrich and his water wagon are in front of the new construction. (Stoddard.)

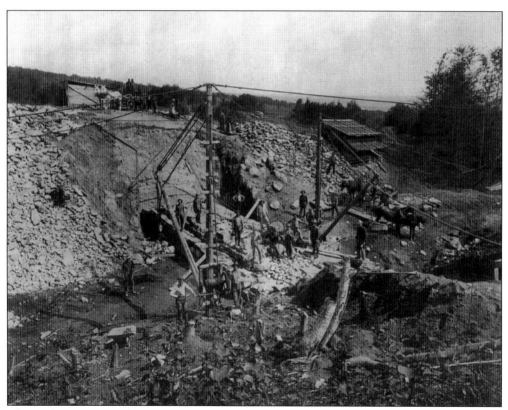

This is the quarry on the side of the mountain behind the prison. These stones were used to build the new wall.

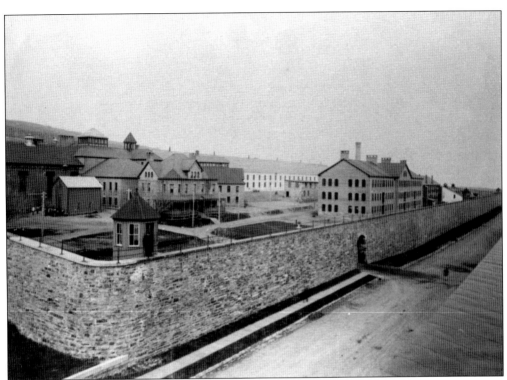

Pictured here in 1894 is the prison with the administration building on the left and the industrial building.

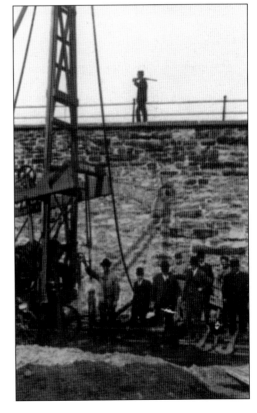

This photograph shows water-drilling operations outside the new stone wall.

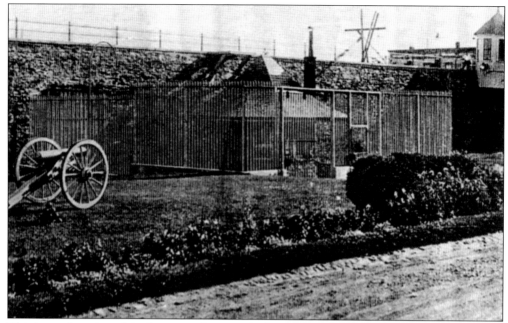

This is another view of the front gate from inside the wall. Note the drill rig outside the wall and the cannon that was used to send out an alarm when a convict escaped.

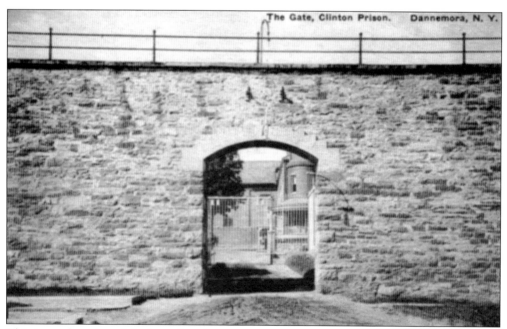

The Gate, Clinton Prison. Dannemora, N. Y.

This is another view of the barred enclosure.

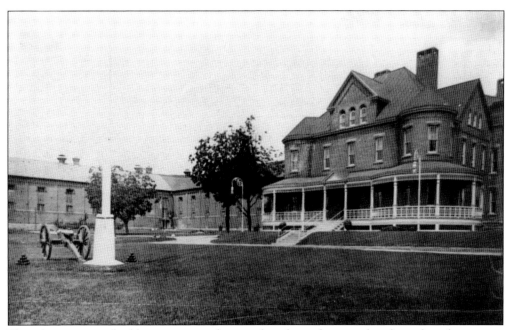

The administration building was a popular spot for taking photographs of guards and visitors.

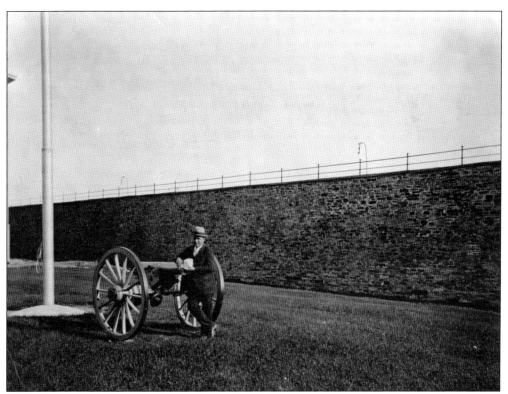

An unidentified gentleman leans against the cannon in front of the administration building.

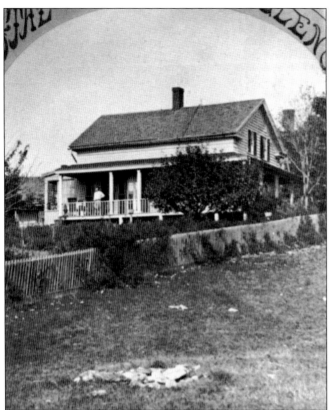

Pictured here is the early warden's residence. During the Victorian era, the well-to-do residents of Plattsburgh, New York, would often take excursions by carriage to visit the prison and take in the spectacle. This practice came to a stop early on.

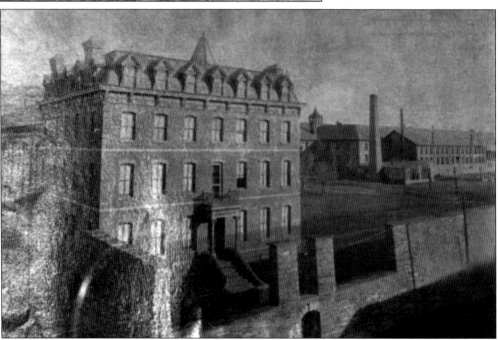

This is the new warden's house before the porches were added. The stone walls and iron gates were taken down, and one of the prison walls was moved.

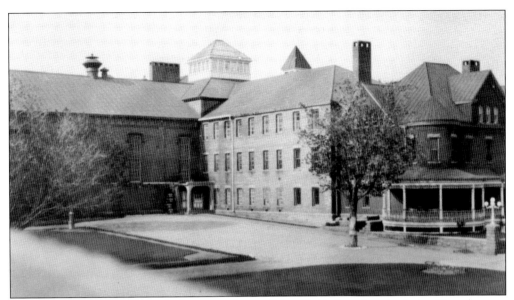

In 1892, Dannemora became the location of one of New York's first electric chairs. Over the next two decades, 26 men were executed within its walls. The first to die was Joseph "Cal" Wood, who was strapped into the chair by warden Walter Thayer on August 2, 1892. This photograph shows the building in which the electric chair was located, behind the administration building.

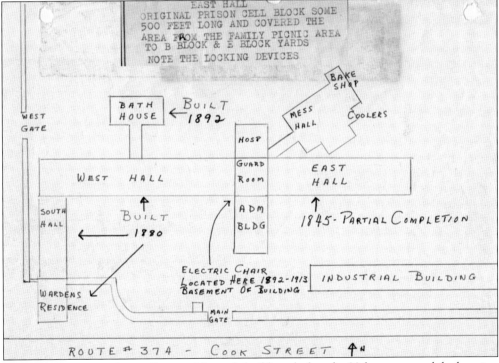

This chart gives a good overall view of the early buildings before the 20th century and the location of the electric chair. There were five more executions before 1900: Karnel Loth in 1893, James Martell in 1893, Martin Foy in 1893, and George H. Smith and Charles David on the same day, October 29, 1895.

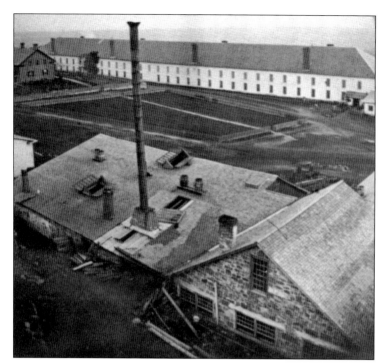

This is a Stoddard photograph of the rolling mill and nail factory. The view is looking southeast, taken from the high post. To the left is the PK's house, and the first cellblock sits in the background. (Stoddard.)

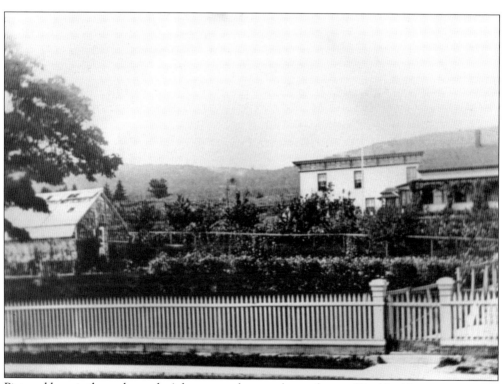

Pictured here is the early warden's house, gardens, and greenhouse. (Stoddard.)

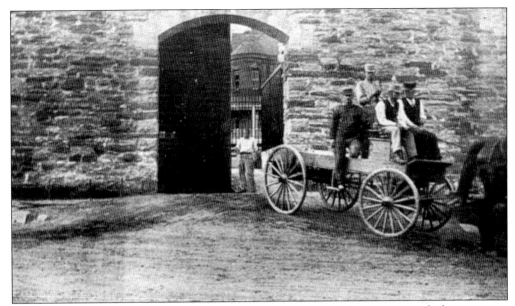

In this early-20th-century photograph, one can catch a glimpse of the iron gate and administration building in the background.

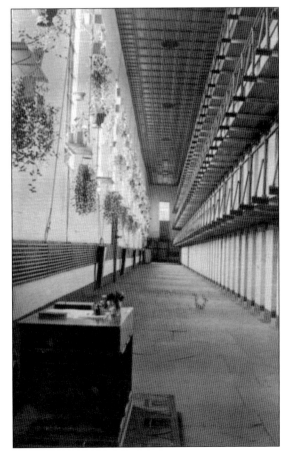

Note the flowers on the walls across from the cells in West Hall, perhaps strung up for a little touch of the outside. (Stoddard.)

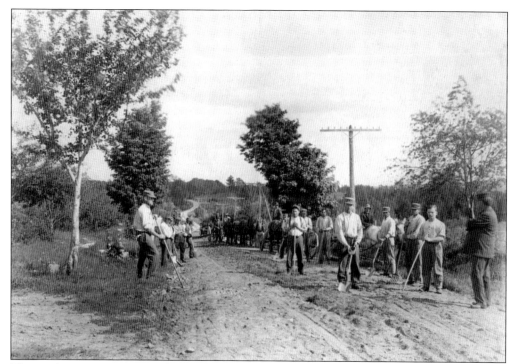

The roads were nonexistent during the time of the mining operation in the prison and were reported as such in the local newspapers. When mining became an unsustainable industry, the convicts were used for local road work.

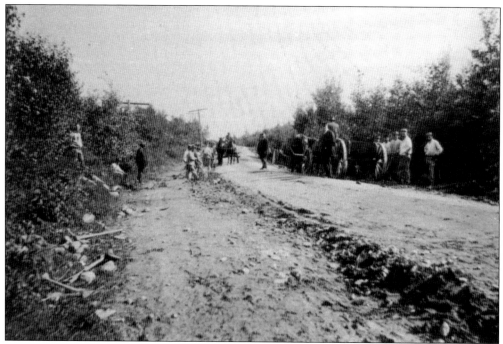

The convicts were also used for grading a roadbed for the railroad from Plattsburgh to Dannemora and then on to Lyon Mountain.

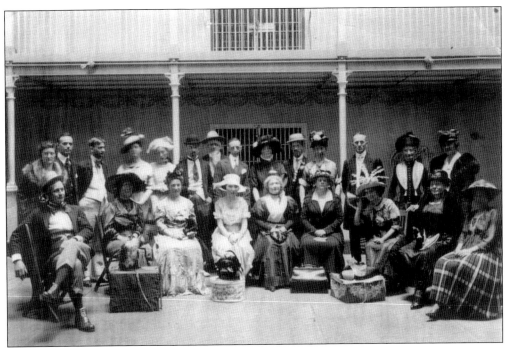

This is an acting troupe, visiting the prison to entertain the convicts.

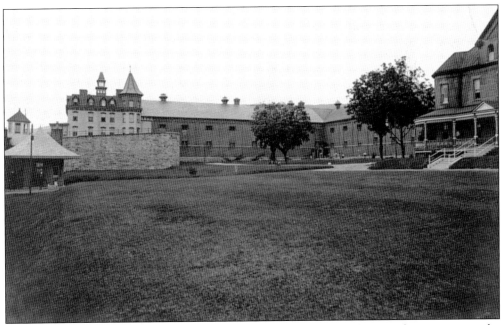

Inside the prison, the walls are still stonework, and work on the warden's residence appears to be under way. The administration building is visible to the right.

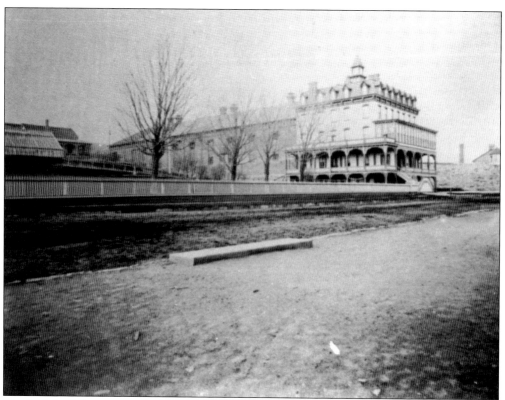

On the left of the new warden's quarters is the old residence and greenhouse.

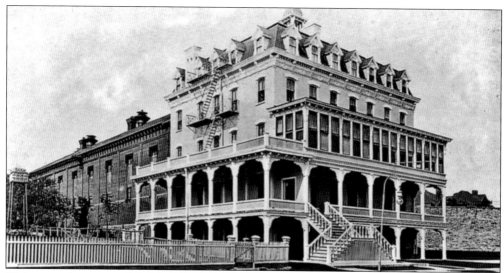

This is another view of the new warden's residence. A prominent building in Dannemora for many years, seen here with the matching birdhouse, it is now gone.

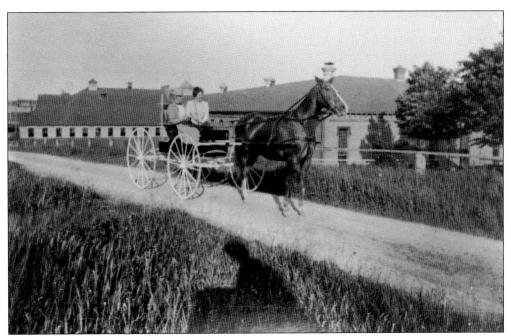

A buckboard ride around the prison was a pleasant way to enjoy the day on unpaved roads. This is a more modern photograph, but it represents the early mode of transport.

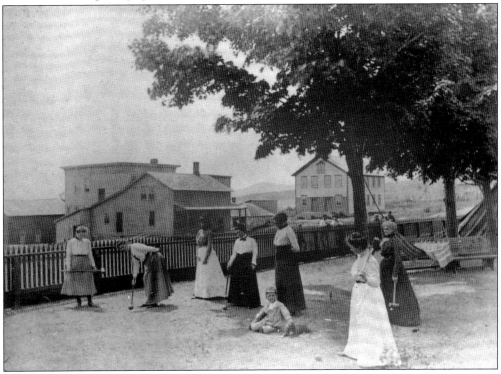

These ladies are playing croquet in the garden area of the warden's residence. Note the first schoolhouse in the background and the structure with the overhanging porch. This building would later become a landmark hotel and saloon called McCorry's.

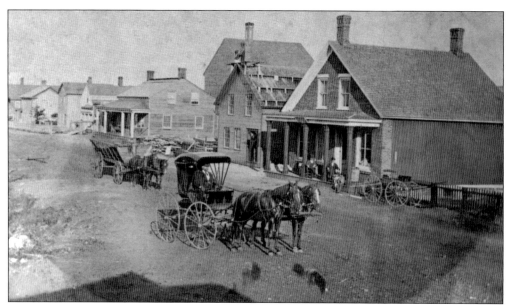

This is the earliest known photograph of Main (Cook) Street, captured in 1870. The horse and buggy driven by Dr. Haynes from Saranac Valley is in front of the first post office. Mail service arrived on January 17, 1850, and James Gibson was postmaster of Dannemora. The Dannemora House hotel is in the background.

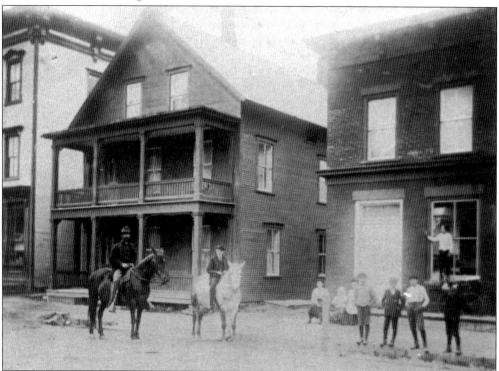

This is another early photograph of Cook Street, around 1880. The Buck Block building is on the far left, and a Keenan building in back of the horses still stands today, along with the Keenan-Breen Building on the far right.

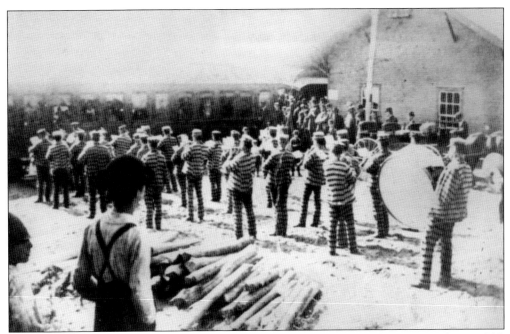

The prison band is playing at the railroad station, welcoming Pres. William McKinley in 1897. The station was later referred to as the small station when it was replaced in the 1900s. It was then used as a freight station and GLF farm supply store.

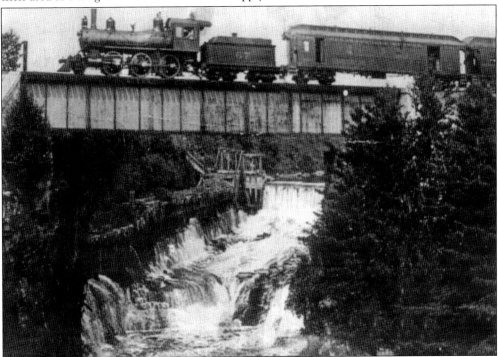

The railroad from Plattsburgh to Dannemora was completed in December 1878. The railroad was built by the State of New York and was transferred to the Chateaugay Railroad Company in 1881. This photograph shows one of the early engines crossing the Saranac River at Cadyville.

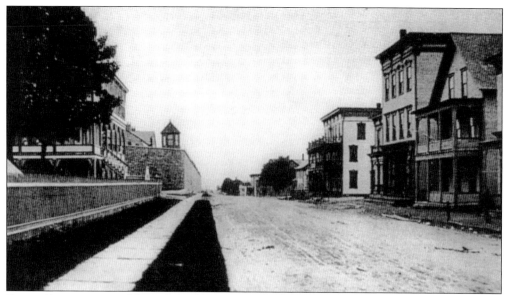

Pictured here are some of the early buildings along Cook Street. The warden's residence and gardens are on the left. Just visible on the right is one of the Keenan buildings, later Leo Breen's. The next building was also William Keenan's, followed by the Buck Block and Adirondack Hotel.

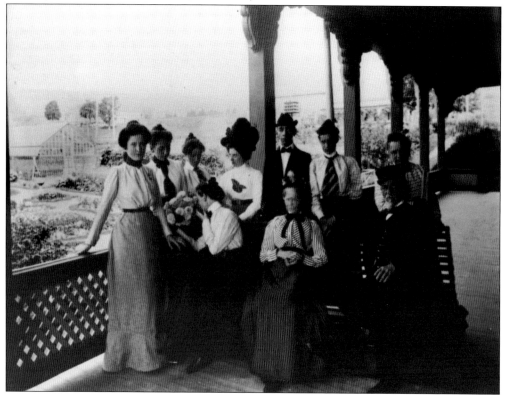

Some early visitors to the warden's residence pose for a photograph on the porch. The gardens and greenhouse are visible to the left. The warden was a political appointment, and as such, he entertained often.

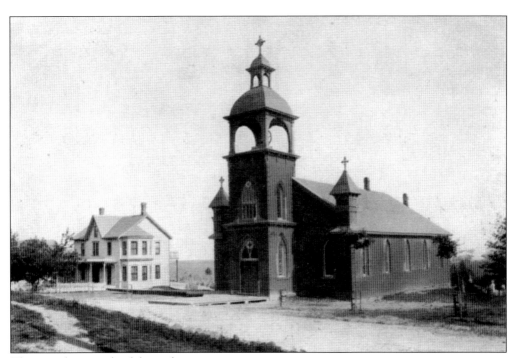

This is a photograph of the early church. The history of the Catholic church in Dannemora started with missionaries, as did most churches in the area. Dannemora was under the protection of St. Peter's in Plattsburgh from 1853 to 1889. On August 1, 1858, the mostly French-Canadian parishioners decided to build a chapel.

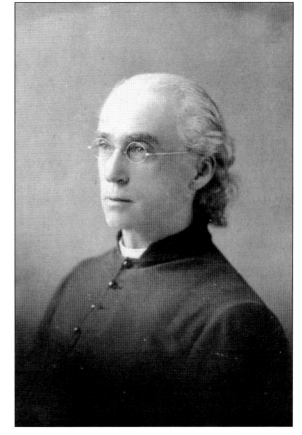

George Belanger was appointed the first resident priest in 1883. He led St. Joseph's Parish for 32 years, until his retirement in 1915. During his tenure, he was also chaplain at the prison. Masses were said by Father Belanger on the first Sunday of each month.

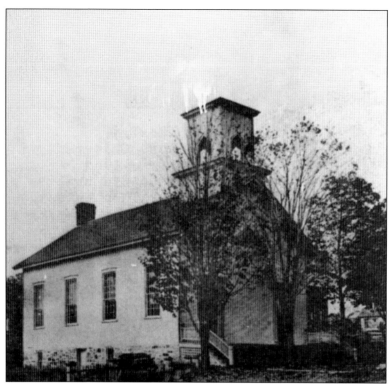

In 1869, the Methodist church was dedicated in Dannemora, at a cost of $4,325. It had organized in 1855 with 33 members. The church was located at the corner of Barker and Bouck Streets, where the high school building still stands. Before that, circuit riders served the community, and the first Sunday School was organized in 1852.

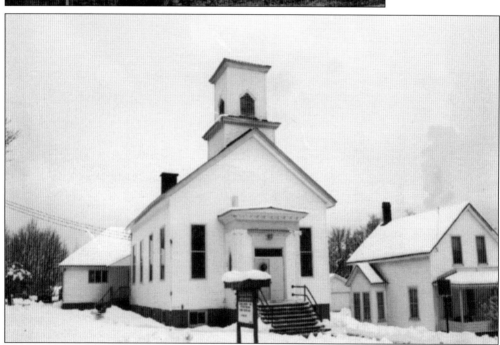

This is the church at its present location in 1955. It was moved in 1929 to the present location on Clark Street. Seeing it moved along Bouck Street was quite a sight. The structure was put on rollers and pulled along by teams of horses. It is now known as Dannemora Community Church, or United Methodist.

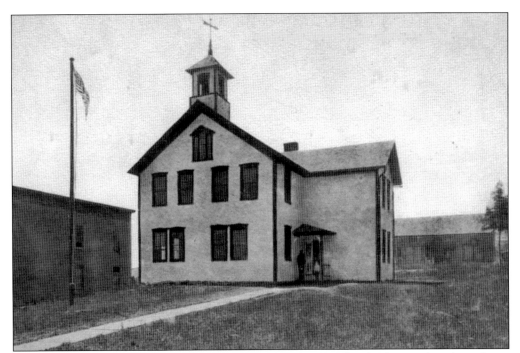

In 1846, the first schoolhouse was erected, with Electra Hammond as the first teacher. Attendance cost 25¢ to 30¢ per child, per week. It was located on the corner of Cook and Emmons Streets. It was later moved across the street and up the hill to become the first fire station.

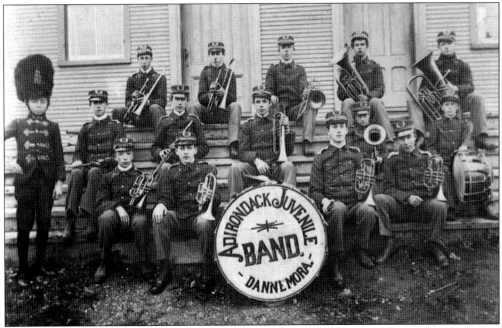

The Adirondack Juvenile Band poses in front of the schoolhouse. From left to right are (first row) William McCorry (standing), Louis Levine, Stephen Nash, Simon Alpert, and Bert Burdick; (second row) Seth Lewis, Norman Burdick, Walter Robarge, Hyman Alpert, and Maynard Cumm; (third row) Fred Myers, Issac Yuddson, Samuel Judge, Fred VanGorder, and Harry McCorry.

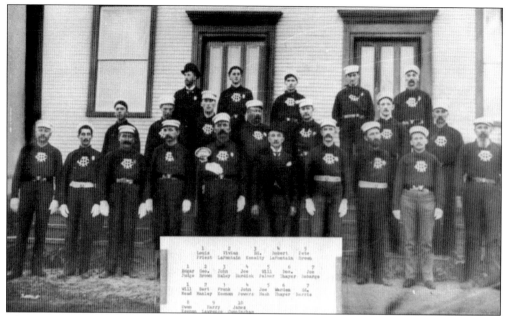

The fire department stands in front of the old schoolhouse. Pictured here from left to right are (first row) Will Mead, Bert Manley, Frank Keenan, John Poers, Joe Nash, Warden Thayer, Ed Norris, Owen Keenan, Harry Lawrence, and James Cunningham; (second row) Edgar Judge, George Brown, John Haley, Joe Burdick, Will Palmer, Doc. Thayer, and Joe Robarge; (third row) Louis Priest, Vivian Lafountain, Ed Kenelty, Robert Lafountain, and Pete Brown.

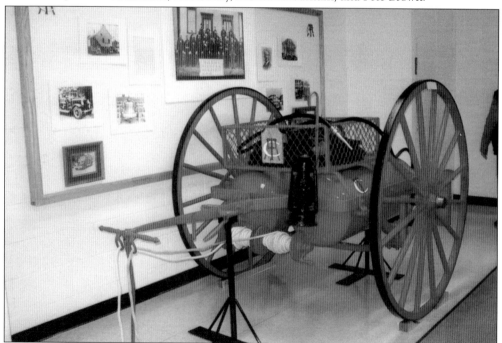

In 1894, the fire department was organized by Walter N. Thayer. Warden Thayer saw the real need for the department, due to many fires in the village and prison. This is a chemical pumper now in the village museum.

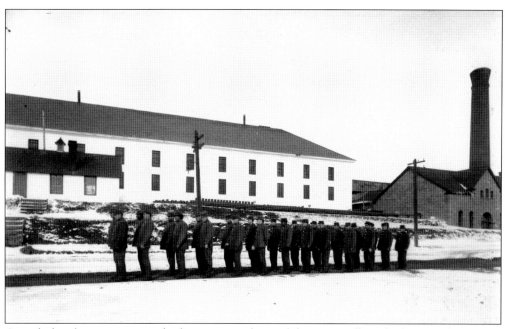

A work detail musters up inside the prison in front of the East Hall, with the powerhouse and smokestack visible to the right.

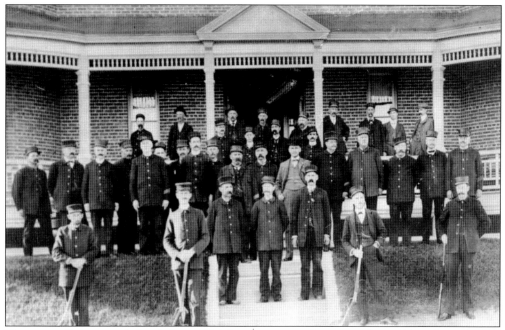

This is a staff photograph dated about 1902. For many years, this spot in front of the administration building was where the guards had their portraits taken.

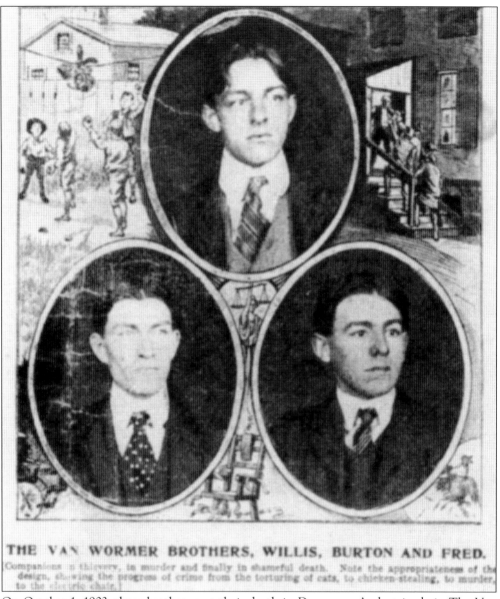

THE VAN WORMER BROTHERS, WILLIS, BURTON AND FRED.

[Companions in thievery, in murder and finally in shameful death. Note the appropriateness of the design, showing the progress of crime from the torturing of cats, to chicken-stealing, to murder, to the electric chair.]

On October 1, 1903, three brothers met their death in Dannemora's electric chair. The Van Wormer brothers were convicted of murdering their uncle on Christmas Eve 1901. Willis, Burton, and Fred Van Wormer were electrocuted in the late morning. Fred, the youngest, was discovered to be moving after being laid down. An attempt was made to put him back in the chair, but he died shortly before the attempt.

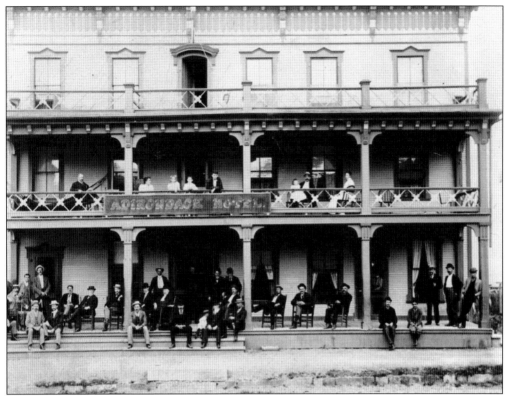

This is the Adirondack Hotel, built in 1875 by Jeff Roberts. J.S. Meader and sons were the proprietors. Fire destroyed the hotel on January 22, 1922.

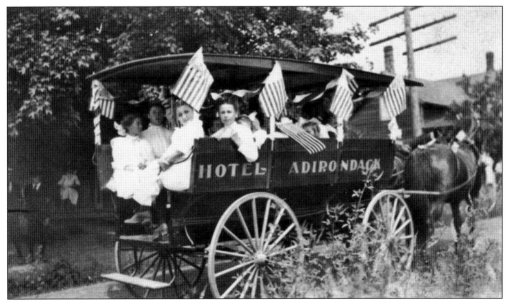

A horse-drawn float advertises the Adirondack Hotel. This was a popular spot for visitors and businesspeople, located across Cook Street near the old prison gate.

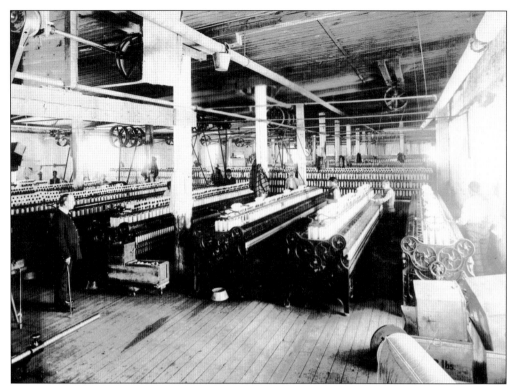

With the closing of the unsatisfactory mine operation, the state turned to other projects. This is the early-20th-century cotton mill in operation.

On May 4, 1899, Gov. Theodore Roosevelt affixed his signature to the act that would establish the Dannemora State Hospital. It would be used to confine and care for insane convicts. This is a view of the land to be used, east of the prison.

Pictured here is a young Dr. J.B. Ransom. He was the prison physician and surgeon in 1889, when he reported the radical increase of cases of tuberculosis. He and the warden made many changes in the hospital facilities for treatment until a new hospital was built.

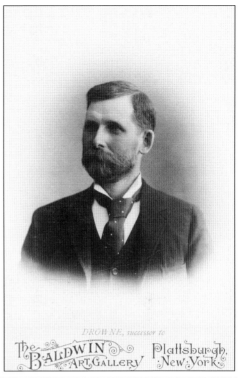

DROWNE, successor to

The BALDWIN ART GALLERY · Plattsburgh, New York

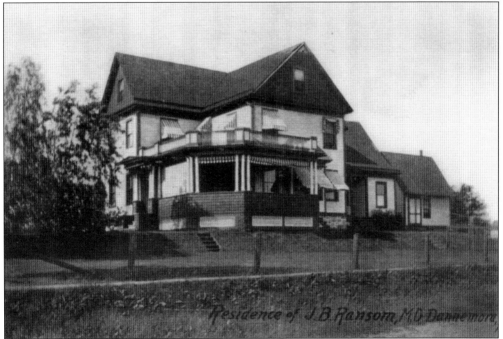

This is the residence of Dr. J.B. Ransom on the corner of Smith and Mason Streets. Ransom died on March 8, 1923, and a special train from Plattsburgh carrying his many friends from around the state arrived. The house was later occupied by Dr. Leaman H. Caswell, also a physician and surgeon at the state hospital.

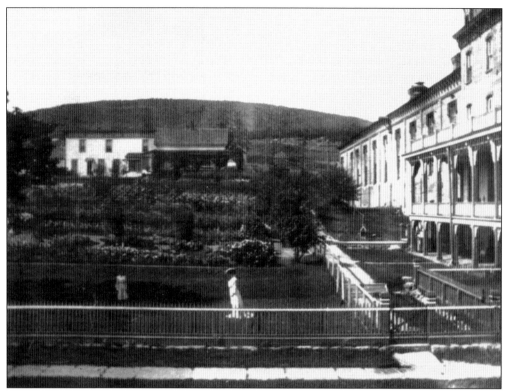

Pictured here is the warden's residence in the early 1900s, showing the early gardens and older residence. Barely visible is a birdhouse that looks like the residence.

Another gathering poses on the front porch of the warden's residence. One can see some of the early building on Cook Street, as well as the corner guard post.

There were more executions after the Van Wormer brothers in the early 1900s. The chair used for all executions in Dannemora was built in Auburn by Edwin F. Davis, who was also the executioner. The last and 26th execution was Fred Poulin on February 12, 1913.

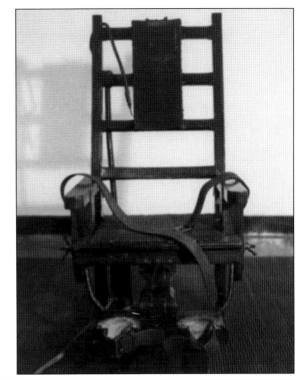

In the past, this was the burial wagon. Some of the executed were carried to the prison cemetery on this wagon, as well as those who died of natural causes in prison.

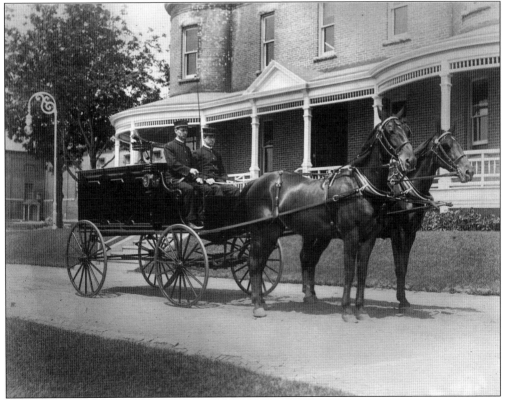

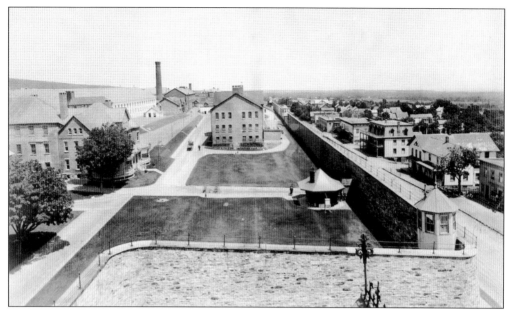

This photograph shows an overall view inside the prison and Cook Street. The old buildings are visible along the street, and the powerhouse, administration building, and old industrial building are inside.

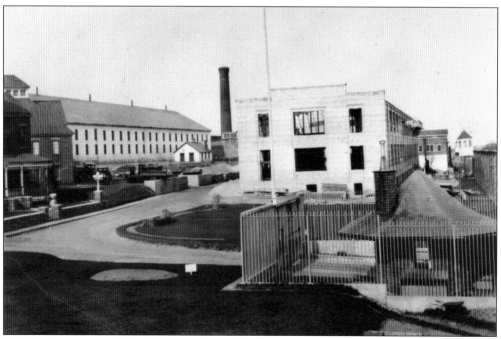

This is a better view of the old gate and guardhouse around the same time, around 1900.

Two

THE TURN OF
THE 20TH CENTURY

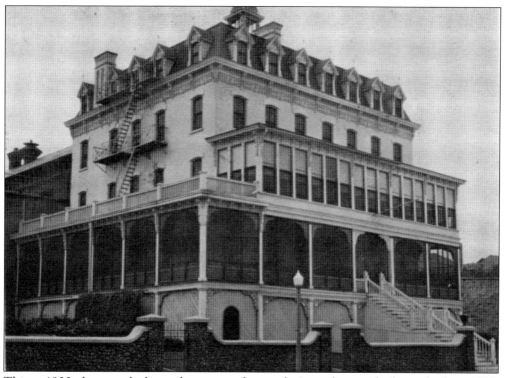

This c. 1900 photograph shows the spectacular warden's residence, which was built in 1880. Twenty successive wardens and their families lived there. The home even boasted its own private gardens.

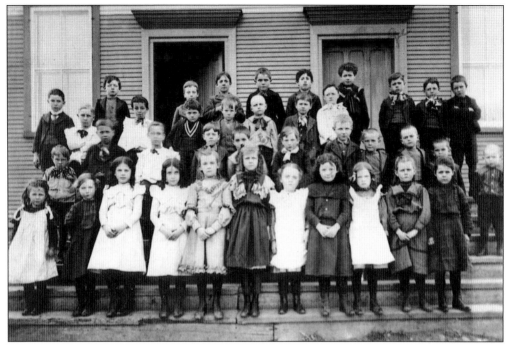

This is an early photograph of schoolchildren outside the first schoolhouse. This is the same schoolhouse that was used as a backdrop for firemen and others' portraits, later moved to be the firehouse.

Pictured here is the warden's family relaxing on the side porch of the residence. In the background are buildings along Cook Street, one of which is the Buck Block. The Buck Block burned in 1945, and Ting Breyette built his restaurant there.

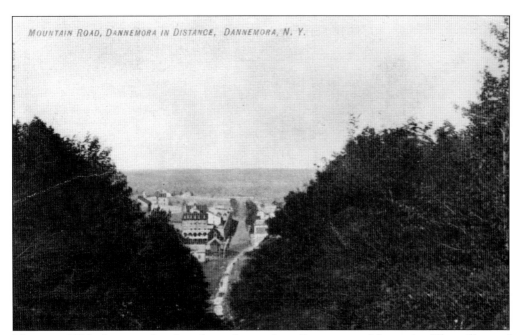

This is a 1909 photograph taken from the road up Dannemora Mountain. The village of Dannemora and Clinton Prison are visible in this eastern view. It also appears that the firehouse is being moved.

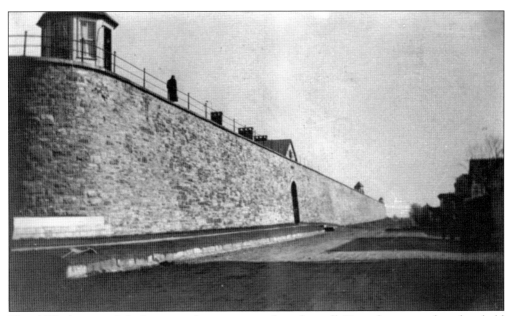

This 1910 photograph looking east shows one guard on the wall. Note the unpaved road and old gate entrance. The sidewalks next to the old wall are paved with slate.

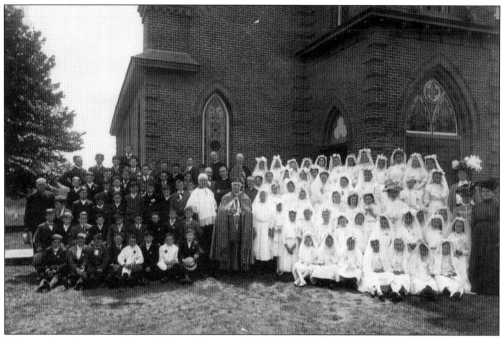

This is Confirmation Day 1912 at St. Joseph's Church. The bishop and early priests were in attendance.

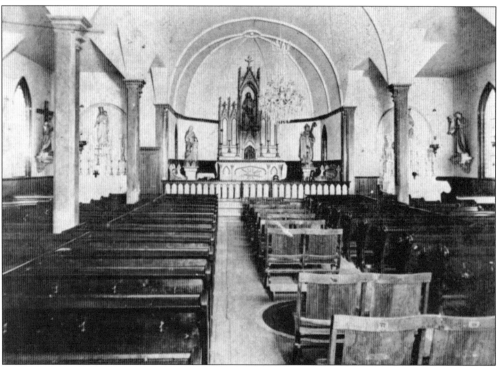

This is the interior of the Catholic church in its early days. This undated photograph features temporary seating in the middle aisle, probably set up for a special occasion such as the confirmation above.

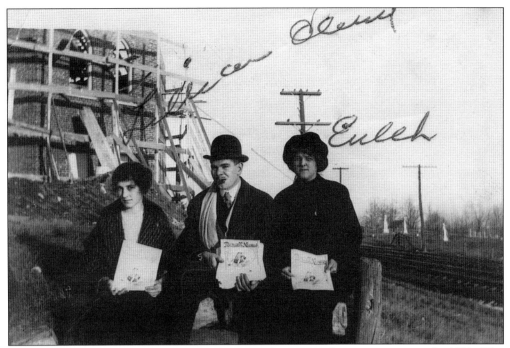

Pictured here St. Joseph's Catholic Church on Smith Street under construction in the 1930s. The railroad tracks and cemetery are in the background. Lillian O'Leary is on the left and Euleh Van Gorder is on the right. The man smoking the cigar is unidentified.

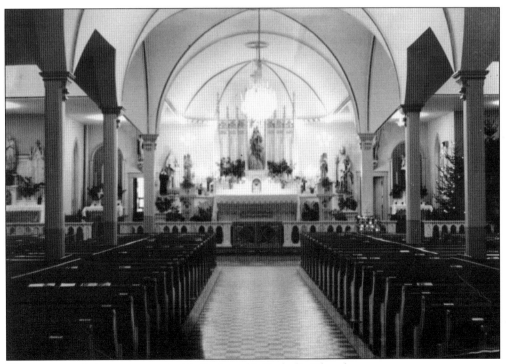

There was much improvement inside St. Joseph's Catholic Church.

Road and street repair and construction was still very important in the growth of the area. Many roads needed to be built to replace the old plank roads.

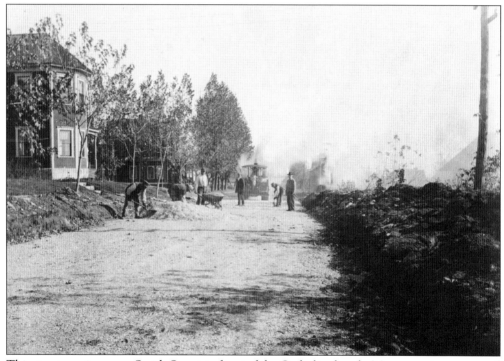

This street repair was on Smith Street in front of the Catholic church. Many convicts were used on road repair, which led to a few escapes.

A Russian group visited the prison on a snowy winter's day. Dressed as Santa Claus and driving sleds and dogsleds, they were quite a sight for the villagers.

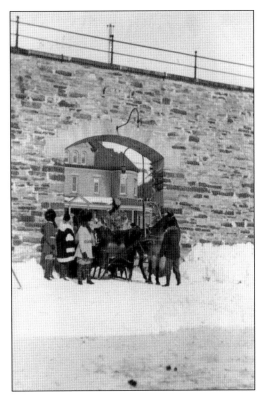

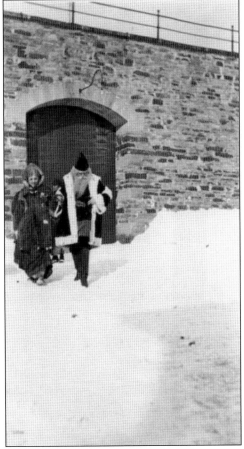

Santa and Mrs. Claus leave the prison. These visits appear to have occurred in the late 1800s or early 1900s, judging from the prison wall and gate.

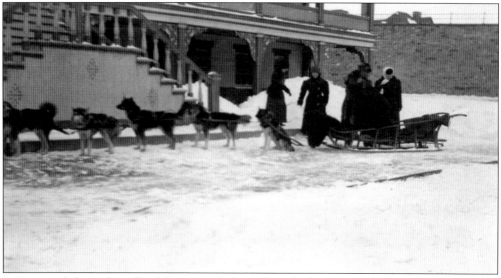

A Russian sled was the talk of the town, dashing through the snowy streets of the village.

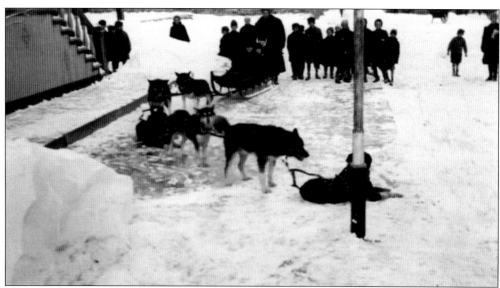

The children of Dannemora never saw such sights and enjoyed seeing the Russian dogsled and Santa Claus. Could this be the origin of Dannemora's nickname "Little Siberia?" Actually, the nickname appears to have come from convict lore, attributed to the horrible winter weather.

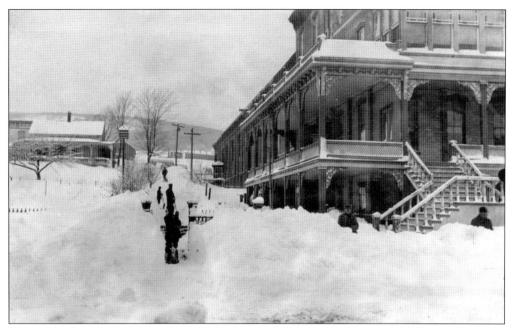

The warden's residence is snowbound. These snowfalls were not abnormal for Dannemora.

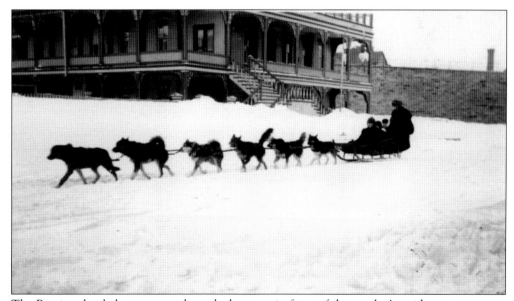

The Russian dogsled team races through the snow in front of the warden's residence.

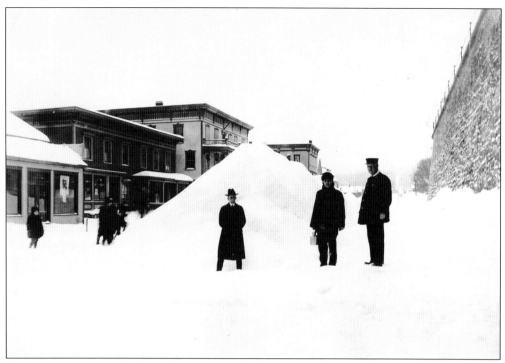

One can just make out the Buck Block over the huge snowbank, but the Adirondack Hotel is visible to the left, followed by the Palmer Block. Steve Thompson is the man in his guard uniform.

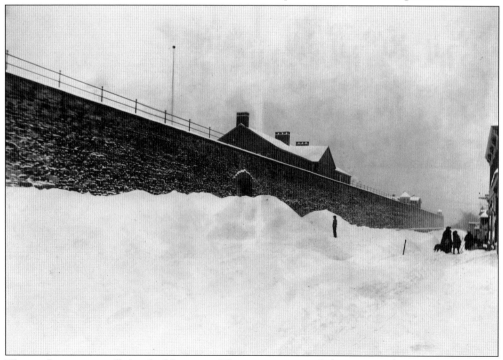

This is the prison wall, banked by snow. This view is toward the east, and one can see people braving the weather on one side and the prison gate just visible.

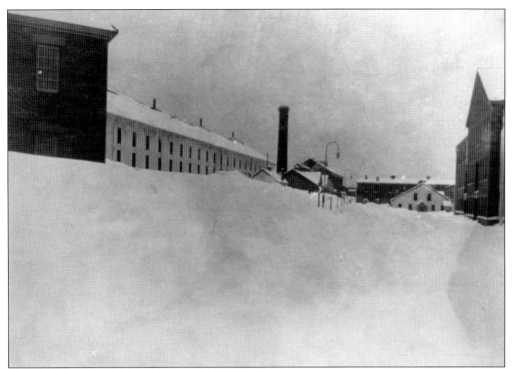

There was not much activity inside the prison during this snowy day. It was another day in the big house, all covered with snow . . . not a convict was stirring, with many years to go.

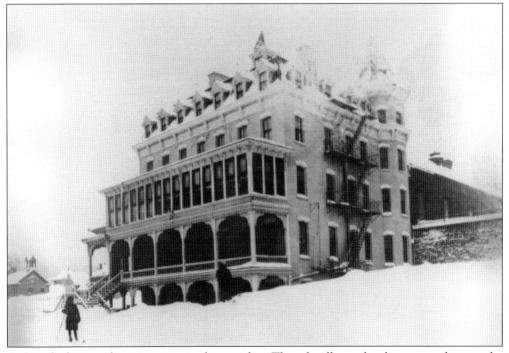

A skier finds it much easier going in this weather. The schoolhouse has been moved across the street and is now the firehouse.

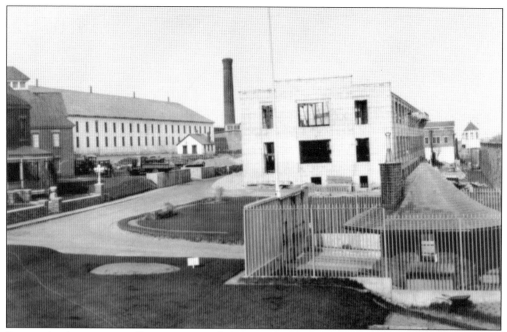

Spring slowly returns to Dannemora and the prison. This photograph was taken in 1902 and shows the old industrial building and powerhouse chimney in the background.

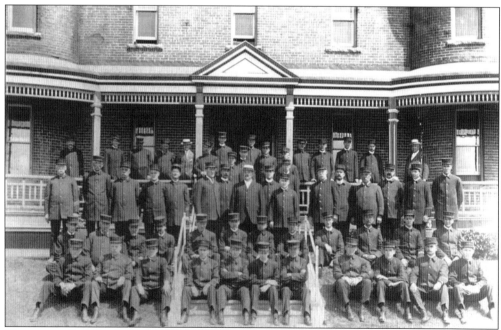

This is a staff portrait dated about 1914, taken again in front of the administration building. In the middle four of the front row is a face the author recognizes. His grandfather John Helmer Bigelow is second from the left.

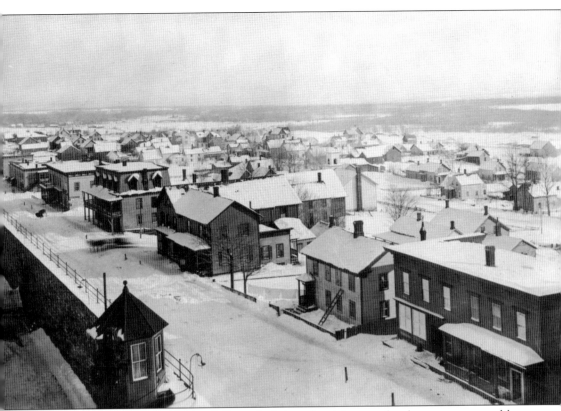

Cook Street is pictured around 1915. From far left to far right are a hardware store owned by Peter and Vivian Lafontaine; a building that housed a dentist and drugstores over many years; the Bromley Hotel, well known as the "Beehive"; the Palmer Block; and the Fitzpatrick Block.

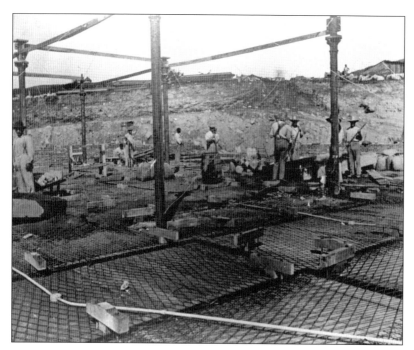

In 1896, $25,000 was authorized for construction of the state hospital. A construction crew of 250 convicts was first assigned to the task. This photograph shows the early foundation work.

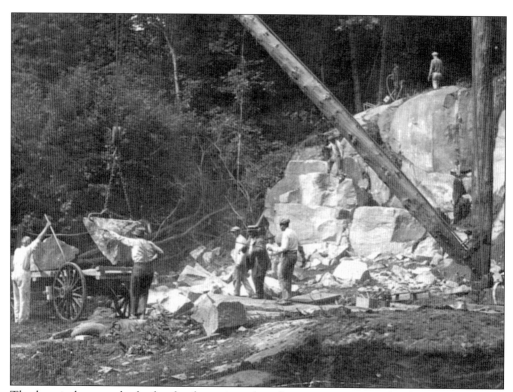

The hospital was to be built of red granite taken from a quarry near the first building. The construction was started under the direction of Clinton Prison warden Walter N. Thayer in the late 19th century.

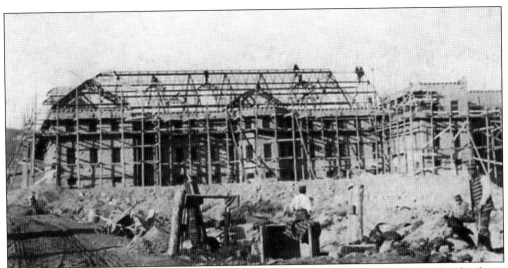

Further appropriations were made, but it still was not enough. More money was needed for plumbing, heating, and ventilation. Convict labor put up a boiler house, dynamo room, and chimney stack. A shortage of iron delayed the construction of roof trusses.

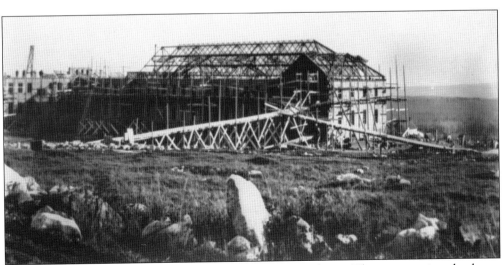

Plans for the hospital were drawn up by L.G. Perry, a state architect. The state continued to hurry the work so that 50 persons could be absorbed from the overloaded Matteawan Hospital.

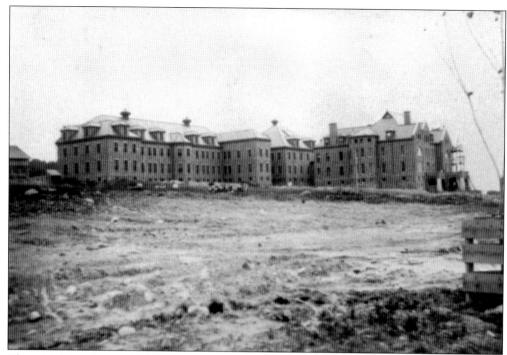

The initial installation included what is now known as Wards One, Two, and Three, as well as the loggia and old attendants' mess. The full capacity of these wards was 150 patients. By 1902, the hospital was overcrowded and new construction was considered.

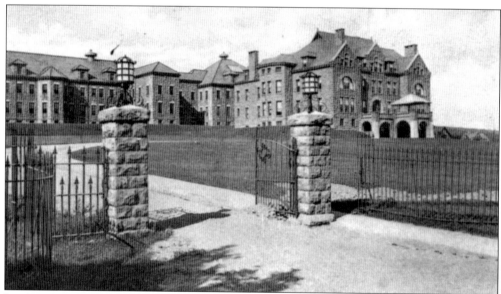

In 1904, Dr. Charles North succeeded Dr. Robert Lamb as medical superintendent. In August 1907, the first serious inmate outbreak occurred when a dozen inmates barricaded themselves in a dormitory. North placed the blame for the outbreak directly on the overcrowded conditions. The uprising was quelled after several hours.

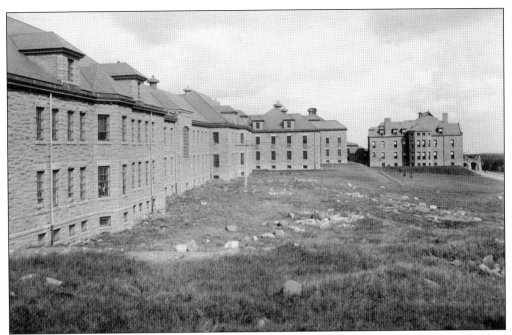

Besides the landscaping visible, improvements inside included the West Wing, rushed to completion around 1910. Another ward and an isolation section were opened a year later. The Southwest Wing was completed in 1915, but the building still could not keep up with the growing hospital population.

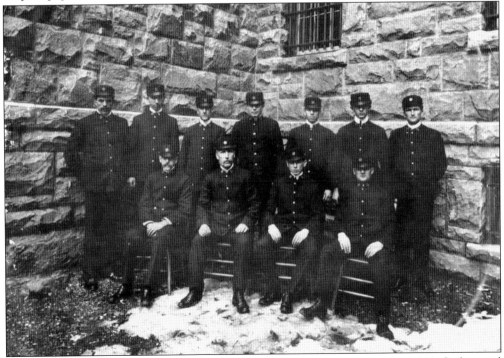

The early hospital staff are standing outside the hospital wall of red granite. In 1914, the hospital was capable of caring for 358 patients. The population had grown to 514 inmates.

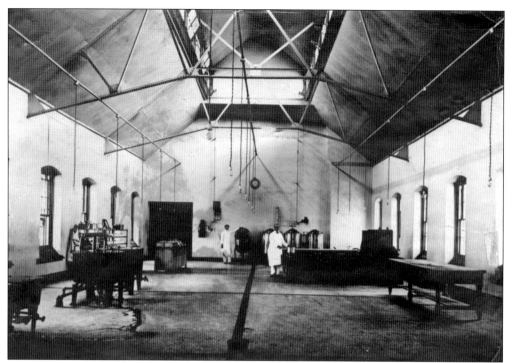

The construction and expansion continued into the 1920s. Ward Six was built in 1922, and then a steward's residence was built. This photograph is of the kitchen area of that period.

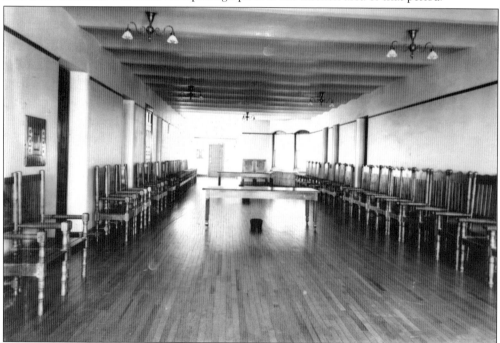

This is a hospital ward, different than the prison with its cells. The most tragic event in the hospital's history was the murder of superintendent Dr. Charles North by a crazed inmate. The date was December 12, 1917, and Dr. John R. Ross was appointed to succeed him.

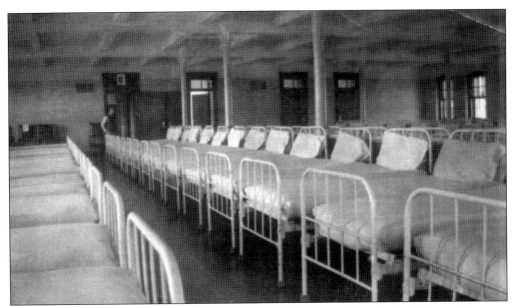

This photograph features an early state hospital dormitory. It was also called a night ward, because patients were usually out in ward halls during the day.

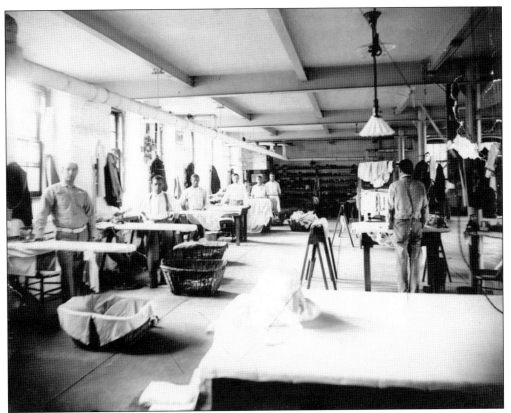

This is the early state hospital tailor shop, around 1916. There were many shops like this for different occupations, and this trend continued well into the 20th century.

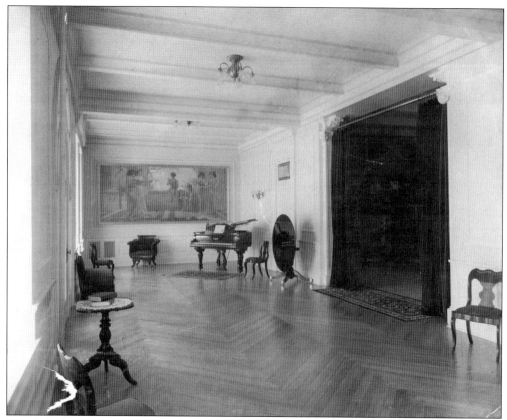

This is the hospital's reception hall, decorated in a classical style. The piano and ornate furniture would not suggest the true nature of the institution.

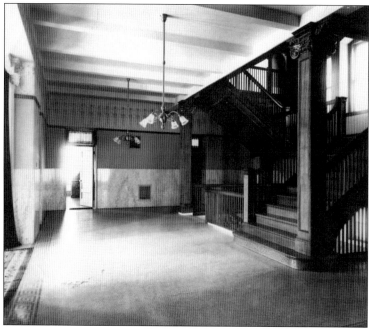

This is the main hall of the state hospital, also decorated in such a way as to improve the institutional look.

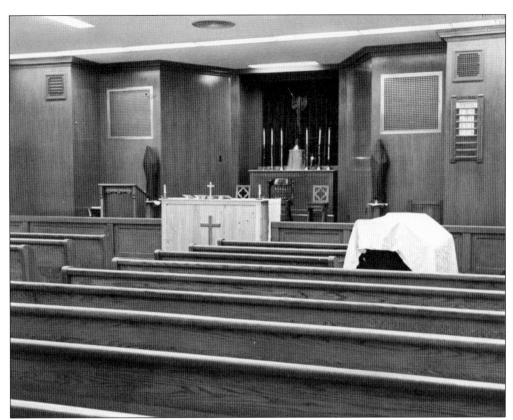

This is the hospital chapel with sliding panels for different faiths. It was located over the mess hall, in what was earlier the old assembly hall.

This is a photograph of the author's father making the change in the chapel. Changing the site from Jewish to Catholic or just the opposite? Near the chapel are the gymnasium and movie theater. His father was also the projectionist at the theater. (Author's collection.)

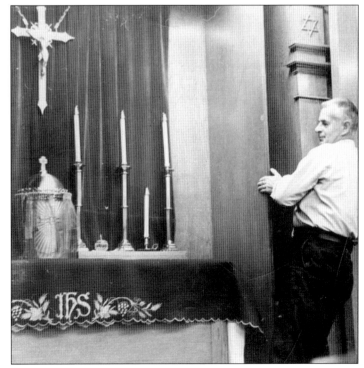

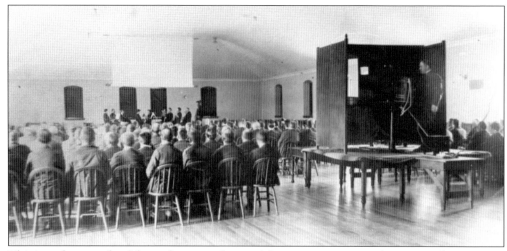

This is a photograph of the early movie theater. Movies were very popular among the convicts, but the movies had to be selected with care. Violent movies and other troublesome topics had to be avoided. Even the PG-rated movies of today would not have been appropriate.

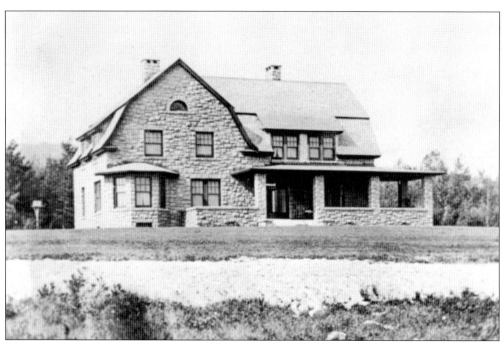

This was the residence of Dr. Ross, and later Dr. Burdick, Dr. Webster, Dr. Francis Shaw, and others who were on the staff of the state hospital for the insane convicts.

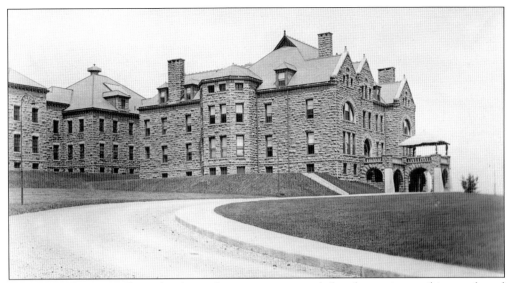

The hospital continued its role of providing treatment coupled with security until it was phased out as a mental facility in 1972. It was reestablished as the Adirondack Correctional Treatment and Evaluation Center (ACTEC). In 1975, the state converted it into the Clinton Annex and classified it as medium security.

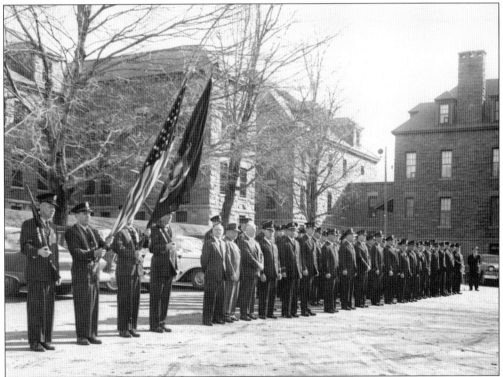

The 1950s hospital staff poses in formation. Merle F. Cooper is on the left after the color guard, facing the camera. His new program was introduced at Clinton Annex, which provided inmates with counseling. He and his deputy, Neil Breen, described inmates that do not even fit in prison society. The annex today has moved to correctional industries, under the trade name Corcraft.

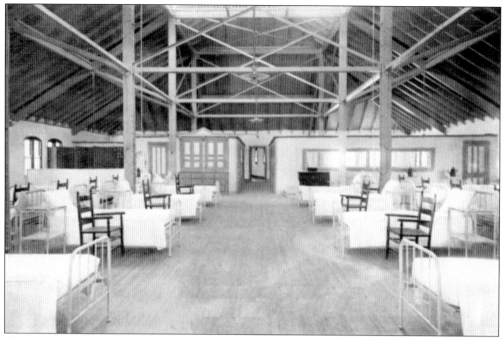

The improved 1907 prison hospital was still not adequate for the tuberculosis patients. It was not until 1915 that appropriations were made for a new tuberculosis hospital.

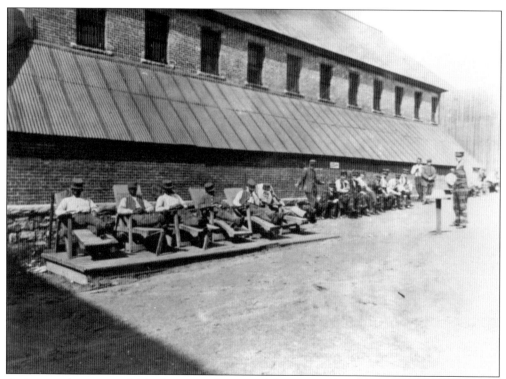

A site was chosen on a high plateau in the rear of the prison. Pictured here are the patients at the new site enjoying the fresh mountain air and sunshine.

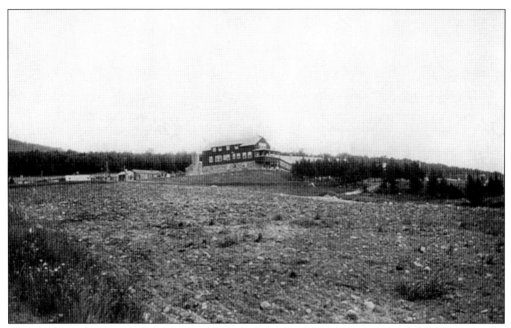

The work on the hospital was accomplished almost exclusively by inmate labor. In 1918, the hospital was completed and occupied with a capacity of 400.

Expansion of the hospital was inevitable, and this photograph shows a more modern structure in 1941. It was left abandoned for many years in the 1950s.

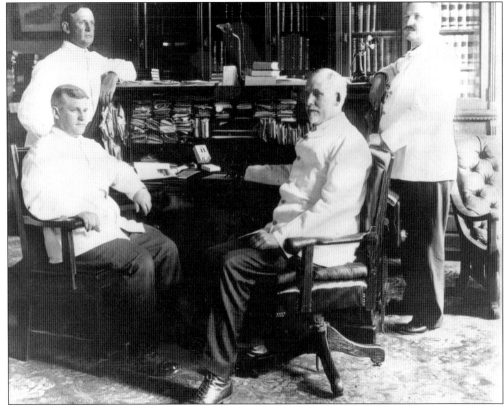

This is the medical staff for Clinton Prison and Tuberculosis Hospital. From left to right are an unidentified hospital steward, Dr. Walter N. Thayer, Dr. J.B. Ransom, and pharmacist J.B. Severence.

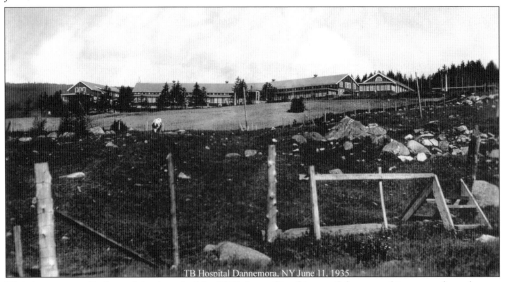

TB Hospital Dannemora, NY June 11, 1935

This is an overall view of the hospital in 1945. It outlived its usefulness and is remembered most for earning North Emmons Street the nickname "TB Hill." The girls who lived there were known as the snobs of TB Hill.

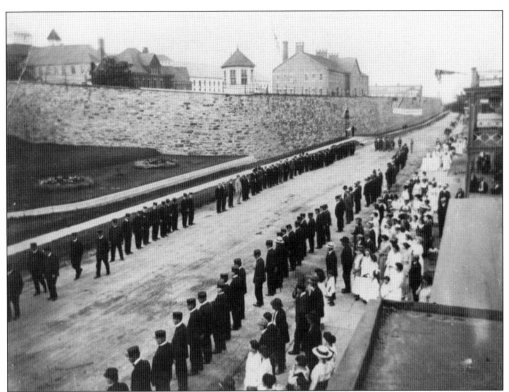

New York governor Charles S. Whitman visited on August 10, 1915, to inspect the prison and hospital progress. He had only recently been elected and served as governor from 1915 to 1918.

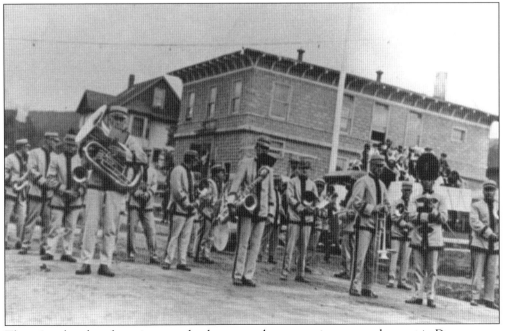

The prison band performs in a parade; they seemed to appear in every early event in Dannemora. The new town hall is visible in the background.

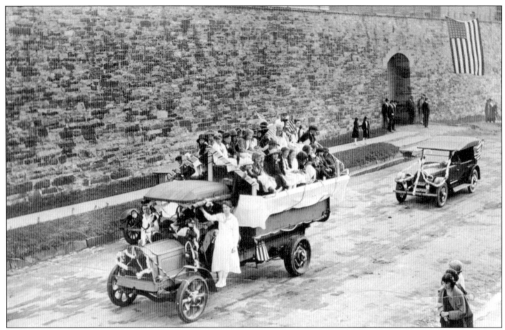

Pictured here is the 1920 Fourth of July parade. Ursula Kaufman was in this parade, and she remembers riding on one of the truck sideboards. She is visible on the prison side of the truck. Dannemora always loved parades with guards from both the prison and hospital.

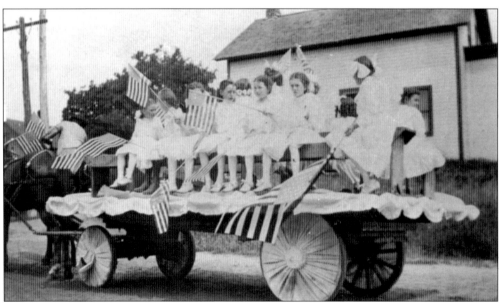

This photograph shows one of the wagons used in a parade. This vehicle was used for different events, such as bond drives, visiting dignitaries, and holiday parades.

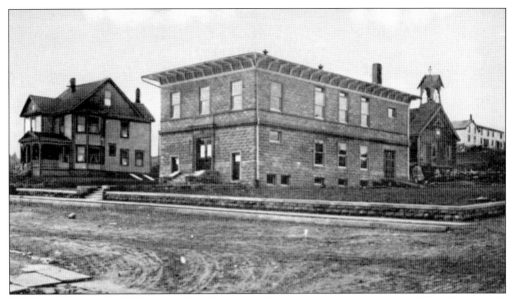

Construction was progressing in the village as well as the prison and hospital. This photograph shows the new town hall, erected after the village became incorporated in 1901. Note the firehouse in the background.

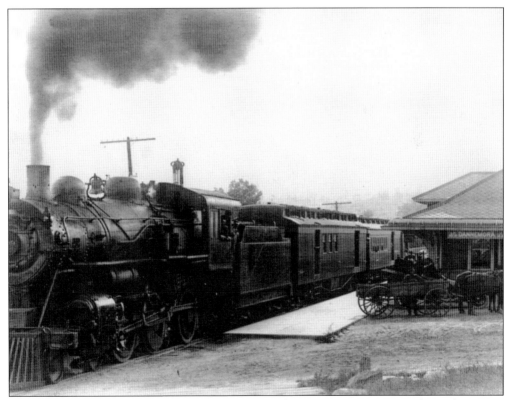

After many months of construction, the new railroad station was open. It was located just west of the old one, near the Catholic church. The old one was still used for freight.

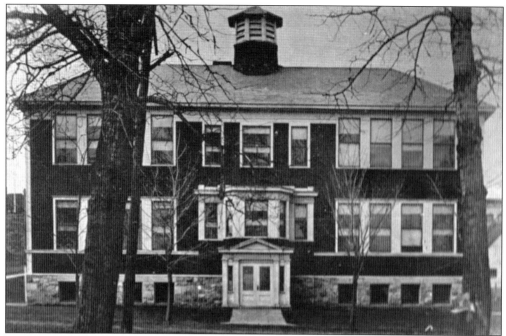

Construction of the new school building was started in 1913 on the corner of Bouck and Flagg Streets. Designed by Max Westhoff, it contained six classrooms, an assembly hall, a playroom, and a supervisor's office. In this photograph, the Methodist church has not yet been moved to its present location.

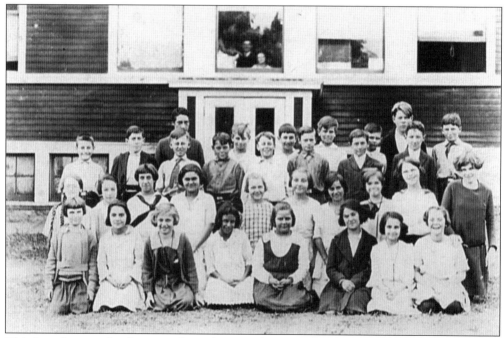

This is a photograph of some early students at the new school in the 1920s. Claude Bigelow, one of the author's uncles, is in the back row. He lived on Smith Street, just a block away. (Author's collection.)

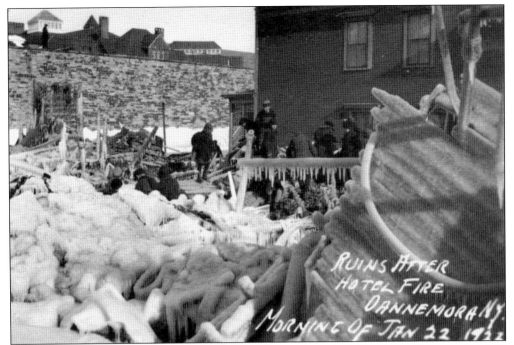

In the early morning of January 22, 1922, a fire at the Adirondack Hotel was discovered at 4:00 a.m. Temperatures were below zero, the village department responded quickly, and warden Harry Kaiser directed that the inmate fire department join the village in fighting the fire.

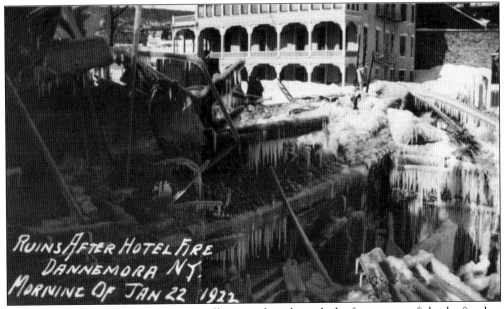

High pressure lines within the prison walls were taken through the front gate to fight the fire, but little could be saved of the hotel. The nearby C.L. Nash Building was saved by the ice-covered firemen. The hotel lay in ruins, covered with ice.

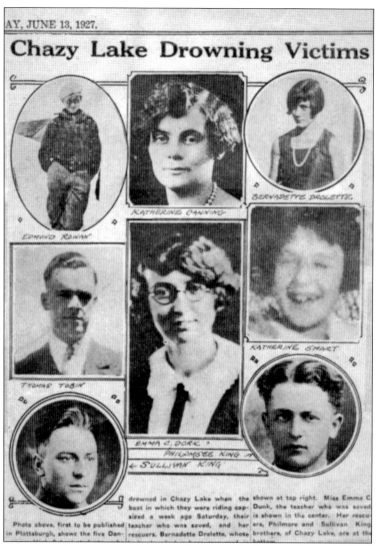

Chazy Lake Drowning Victims

EDMUND ROWAN

KATHERINE CANNING

BERNADETTE DROLETTE

THOMAS TOBIN

KATHERINE SMART

EMMA C. DUNK
PHILOMBEE KING
SULLIVAN KING

drowned in Chazy Lake when the boat in which they were riding capsized a week ago Saturday, their teacher who was saved, and her rescuers. Bernadette Drolette, whose shown at top right. Miss Emma C. Dunk, the teacher who was saved, is shown in the center. Her rescuers, Philmore and Sullivan Kings, of Chazy Lake, are at the Photo above, first to be published in Plattsburgh, shows the five Dan- bottom.

Dannemora experienced many tragedies over the years, both in and outside the prison walls. The Plattsburgh paper wrote, "All mourn with Dannemora in this, her hour of deepest sorrow." The paper was reporting the drowning of students on Saturday, July 3, 1927. The students were rowing in two boats across the lake from the pump house side to the Lyon Mountain. It was the senior class picnic, but the class was so small they invited juniors along, too. The wind was strong and it appears it was coming from the southwest. The wind was not bad when they started out, but as they approached the west shore, it picked up and waves were coming over the transoms of the boats. The boat that was swamped appeared to be overloaded with passengers: Kathleen Smart, Tom Tobin, Bernadette Drollette, Edmund Rowan, Catherine Canning, and teacher Emma Dunk, as well as a small white dog. The boat flipped over, and all were holding on to the boat for a while. They all slipped away from the boat, excepting the teacher, and drowned, including the dog, which was never found. Dunk had caught her hand in the boards of the boat and drifted with the boat into Seine Bay. The people from the other boat ran along the road from the railroad station to the shore of Seine Bay. Emma Dunk was unconscious when they finally got to her in the shallows of Seine Bay. They had to rip her hand out of the boards after many tries, but she was the only survivor. (*Plattsburgh Press-Republican*.)

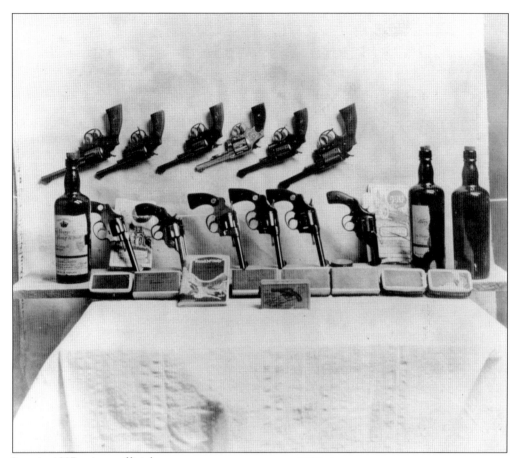

Late in 1927, prison officials were informed of an escape plan. A wooden box addressed to the industrial department from warden Harry M. Kaiser was intercepted. It contained six automatic pistols, 400 rounds of ammunition, three bottles of liquor, and some county road maps.

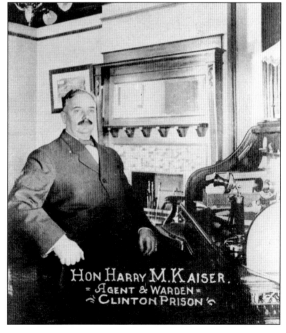

The information came from a snitch, and after the first package, another arrived in the same manner. More guns and ammunition were in this one. Using an identification number on this package, officials were able to trace the box to its origin. Pictured here is Kaiser at his desk.

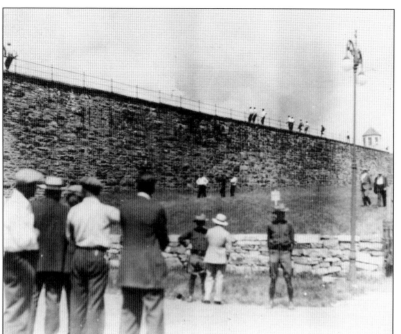

Convicts left the mess hall after breakfast on July 22, 1929. The unarmed guards, unable to stop the milling around, were attacked with stones and clubs. Officer Ernie Bressette was struck by a rock and clubbed. He escaped when shots rang out from the wall, and a convict was shot chasing Bressette with a club.

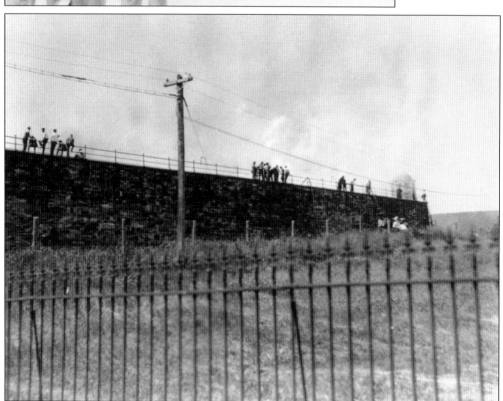

Word of the riot spread throughout the village, county, and even the state. The whole village and prison were brought into play during this riot. Civilians were recruited to man the walls with their rifles. The guards were recently armed with machine guns for times like this.

Reports of 1,300 desperate criminals rioting behind a smokescreen of burning buildings told the story. The rioters torched the powerhouse and smashed the dynamo. Piles of wood shavings from the carpenter shop were also set ablaze. Smoke spiraled upwards, and rioters stormed the walls in spite of withering gunfire.

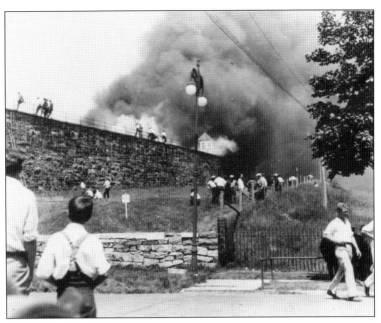

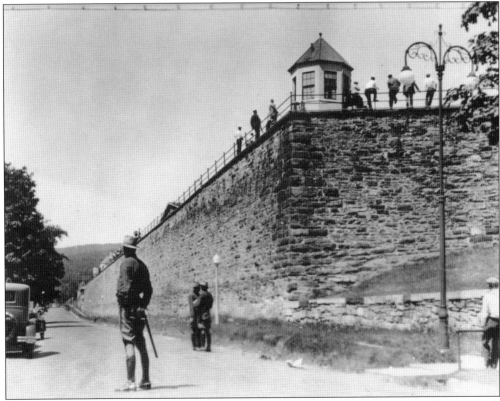

The shrill prison whistle announced the riot situation to the village. Citizens and off-duty guards gathered hunting rifles and ammunition. Assistance from the state police was requested from Malone and Plattsburgh, and they arrived to assist. Game wardens and border patrol officers were also on hand.

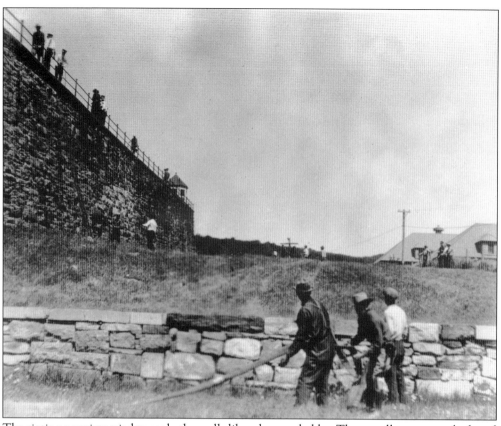

The rioting convicts tried to scale the walls like a human ladder. Three walls were attacked, and machine guns and rifles held firm. With the spread of fire inside the prison, the fire departments hauled the hoses up and pumped water over the wall to extinguish the fires below.

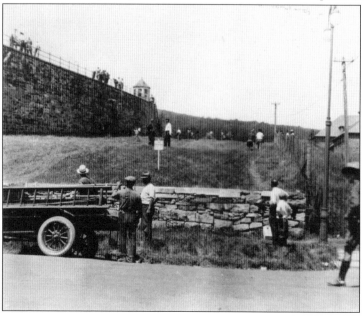

When the state police arrived, they stormed the prison gate and drove back the prisoners. Some convicts went back to their cells cursing. A group refused to give up and burned many shops. Inmates searched the powerhouse looking for civilian employee Peter Dame, but other inmates had hidden him in an unused boiler.

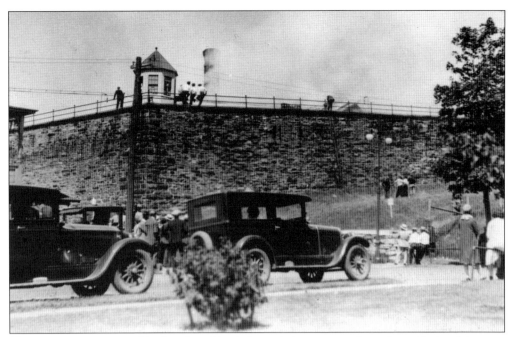

The remaining rioters grabbed tools and hurled metal pieces at guards on the wall. An ultimatum was given to surrender or else grenades carried by the police would be used. A plane flew overhead with photographers, mistaken by the convicts as a bomber. The inmates quit, with three dead and 20 injured.

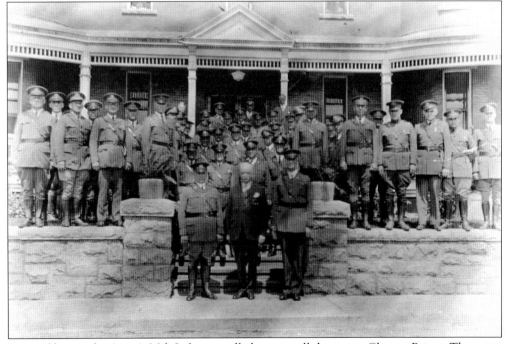

Pictured here is the Army's 26th Infantry, called up to quell the riot in Clinton Prison. They were under the command of Maj. Max Sullivan. With bayonets, hand grenades, and tear gas, they stayed outside the walls. An impressive sight for the citizens, but their services were not rendered.

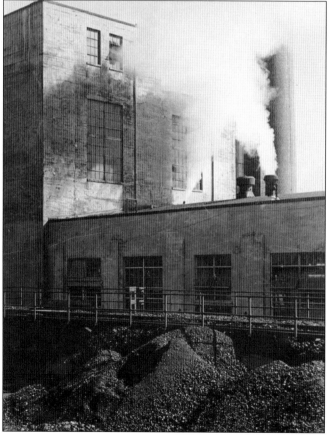

Later in 1929, the pump house on Chazy Lake was built to supply water to Clinton Prison and State Hospital. The water line stretched over the mountain and along the road. Large pipes were buried to supply the reservoirs behind the prison, as the smaller, earlier reservoir was drained during the 1929 riot.

Construction of a new powerhouse was started on the south side of the railroad tracks. The old powerhouse inside the walls was unusable after the 1929 riot. In 1932, warden Harry Kaiser threw the switch to supply heat, steam, hot water, and electricity to both the prison and hospital.

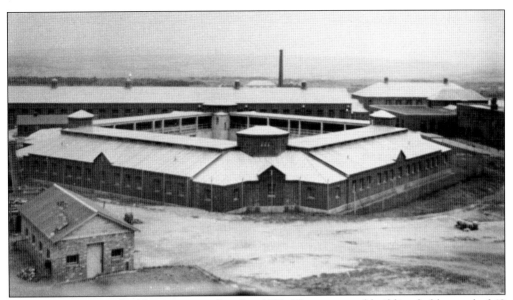

The new segregation building was completed in 1933. The octagonal building held a total of 48 cells. In later years, it was known as Special Housing Unit No. 14. Note the stone crusher shack in foreground.

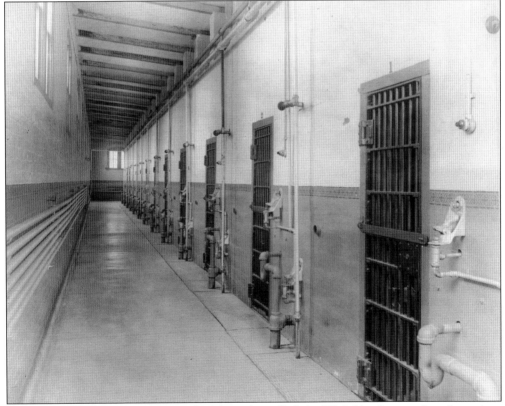

This is the inside of the segregation building, also called the "Hole" by the guards and convicts. It had separate cells for the incorrigibles and 12 cells to each of the four sections.

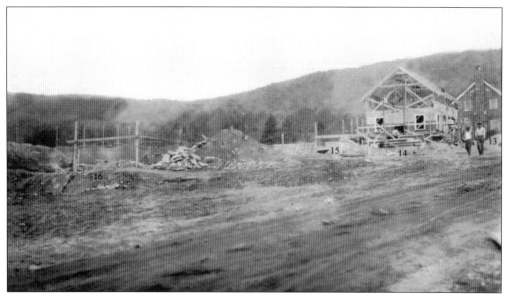

This was the construction site on September 25, 1935, where State Houses No. 13–16 were being built on TB Hill. That was the name given to North Emmons Street, on account of the tuberculosis hospital being located there. In 1937, the state houses were completed.

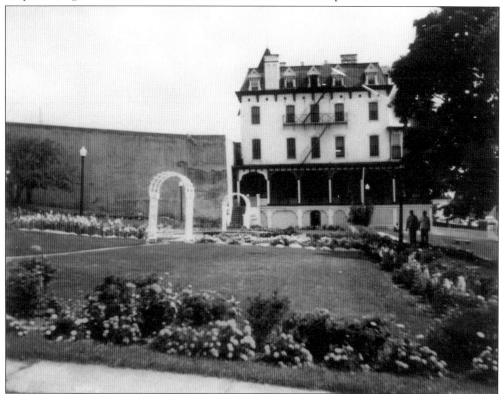

During the years 1931–1939, the warden's gardens and grounds were especially beautiful. At night the fountain was lit with colored lights, and there was a pond filled with colorful fish. A swimming pool on the east side was shielded from the street by lattice and evergreens.

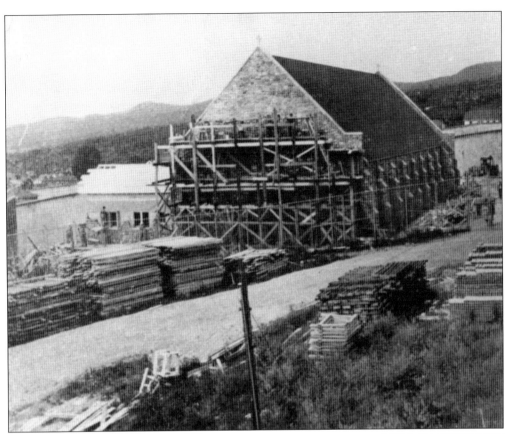

In September 1939, the inmates of Clinton Prison started the construction of the first church ever built inside the walls of a maximum security facility. It was the dream of Fr. Ambrose Hyland, Catholic chaplain, who collected contributions from benefactors from around the country. After much campaigning, he secured permission to proceed.

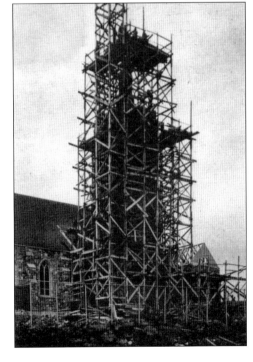

The church was to be called the Church of Saint Dismas, the Good Thief. Stones were salvaged from an old prison wall near the site, and the church had a tower that rose 106 feet. The pews were constructed of Appalachian red oak that was donated by ex-convict Lucky Luciano.

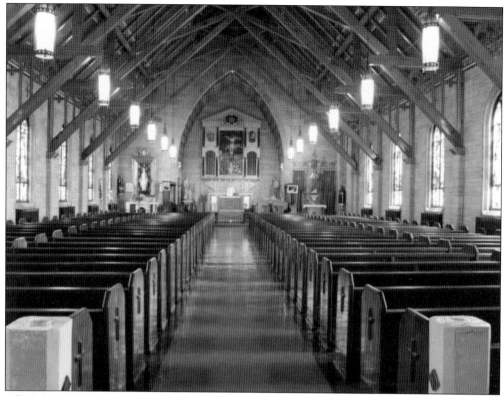

All of the paintings, stained glass, hand-wrought lanterns, and pews were fashioned by inmates. It featured the historical Magellan Altar, brought from the Philippines in 1521 by Ferdinand Magellan. The wood panels imbedded on each side of the crucifix are reportedly from Magellan's ship.

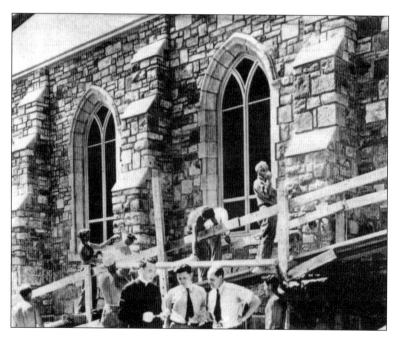

Some finishing work is being overseen by Father Hyland (left), who is conferring with two outside builders. The penny-pinching budget required a substitution of automobile taillight reflectors for rubies in the stained-glass windows.

Imagination led to the creation of this crucifixion image. Convicts made a cross, and another convict stood on a box with his arms up. Before he realized it, his wrists were lashed and the box kicked out from under him. The convict artist was then able to create the look of a man actually undergoing the torment of crucifixion.

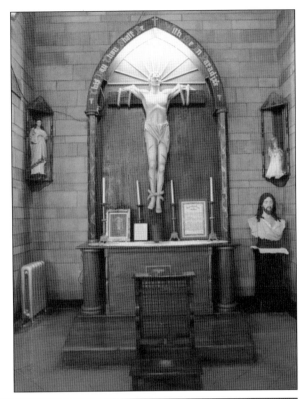

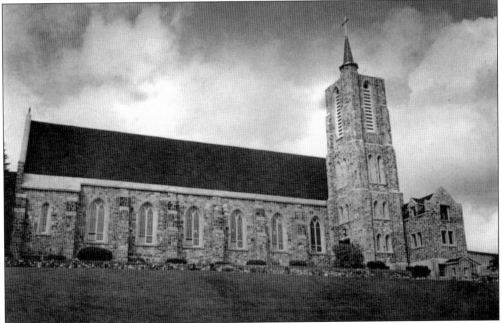

Pictured here is the finished church, dedicated on August 28, 1941. In his dedication, Father Hyland remarked, "A potent force has been unleashed here today, affording an improved perspective . . . and a better life for all humanity, and in particular for the unfortunates who are confined in . . . Clinton Prison."

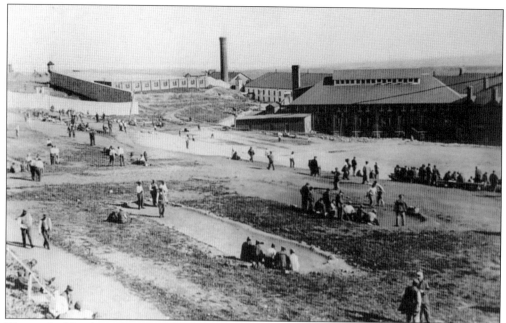

This is the North Yard recreation area before most of the construction in the 1930s. Note the old isolation cells in the background in front of the original smokestack of the powerhouse. This area was used for different games, including lawn bowling.

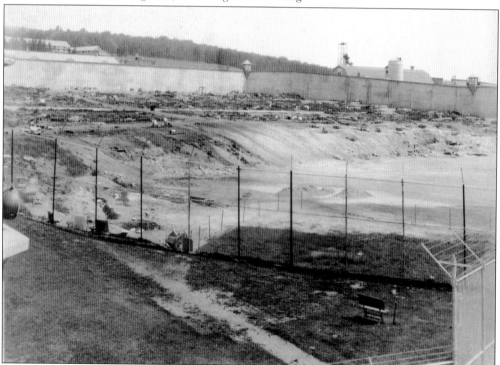

This is the North Yard after most of construction in the 1930s and before the creation of what would later be called the courts. This was the age of the big houses, reflecting a period of tremendous expansion and a staggering increase in crime.

The courts of the North Yard are individual areas used by inmates during recreational periods. It is full of handmade wooden fences, furniture, stoves, and gardens. Groups of inmates are allowed to plant flowers or vegetables, sculpt the earth into terraces, and even cook.

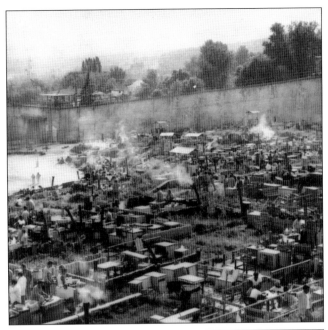

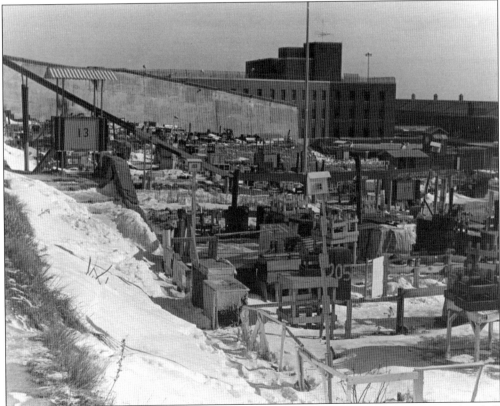

The big yard is about 7.5 acres, with about one-third of this being flats. In this section are baseball and softball diamonds, a basketball court, and in season, a football field. Visible in this photograph is the ski jump that was used in the winter.

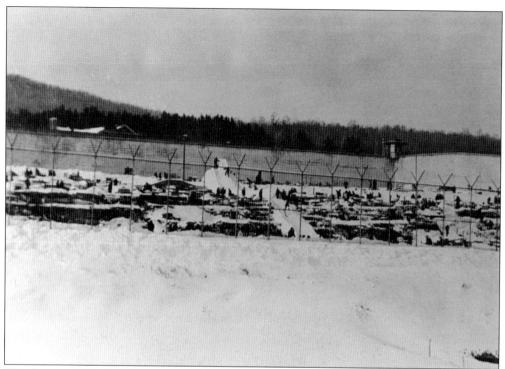

The ski jump was not the only unique sports venue in the North Yard. There was also a bobsled run with a runoff onto the football field. The sleds were homemade by the convicts. There was also a skating rink on the top of the slope behind the courts area.

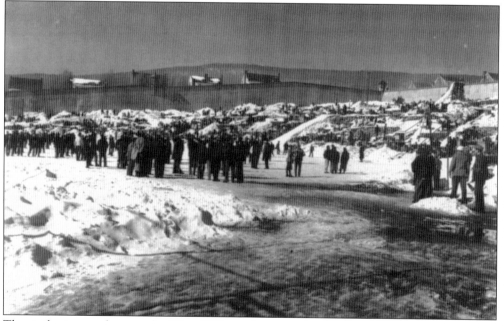

This is the iconic photograph of the ski jump that provokes the most questions. What is this doing inside a maximum security prison? The courts, ski jump, and everything in the North Yard make Clinton Prison a very unique place.

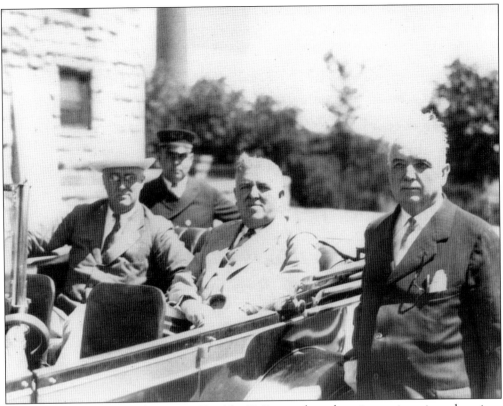

In the early 1930s, New York governor Franklin D. Roosevelt made an inspection trip to the prison and hospital. This photograph shows FDR in his car with Doctor Kieb, the hospital director. Warden Kaiser is standing to the right, with P.K. Grainger behind the car.

This is Eleanor Roosevelt with Earl Miller at Werrenrath's Shanty on Chazy Lake in 1933. She made a second trip to Chazy Lake in August 1934, recounted in *Invincible Summer* by Kenneth S. Davis. (Courtesy of Franklin D. Roosevelt Library, Hyde Park, New York.)

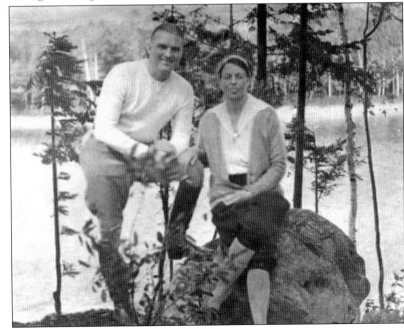

The Fitzpatrick Building in this photograph still stands. Pearl's Department Store was once on the right side near the barbershop. Upstairs was used by the American Legion for its meetings in the 1950s, and on the left below there was a convenience store. This fellow is leaning into the wind.

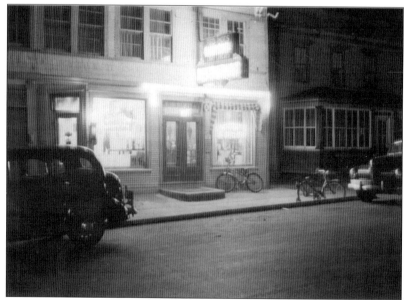

This is a night photograph of the west end of the Fitzpatrick Building. Hank Relation had his barbershop there, and other barbers were Lindy Carl and Sonny Brooks. Next door was the Sugar Bowl, run by the Hadcock family.

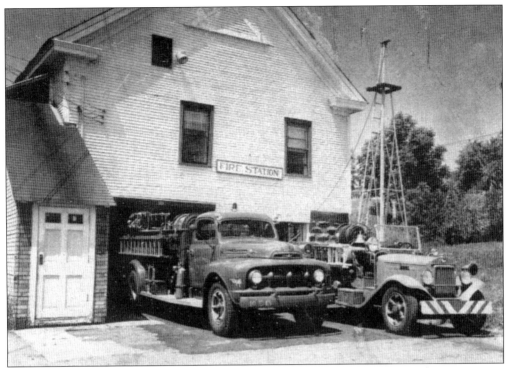

On February 13, 1945, a fire broke out on the Buck Block at about 5:00 a.m. The Dannemora Fire Department made a quick run to the scene with its apparatus. The prison fire brigade was one of the first on the scene as well.

The burning building was owned by the L.H. Buck estate of Plattsburgh. It was occupied by Fred Breyette and Son food market and the post office. Breyette's stock was completely lost, but many furnishings were saved. First-class mail was saved, but everything else in the post office was lost.

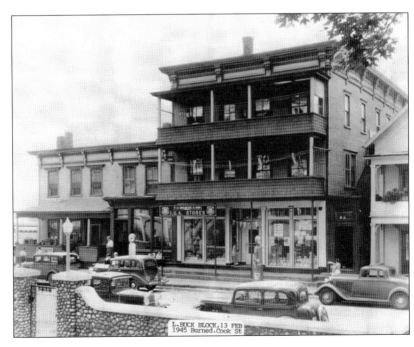

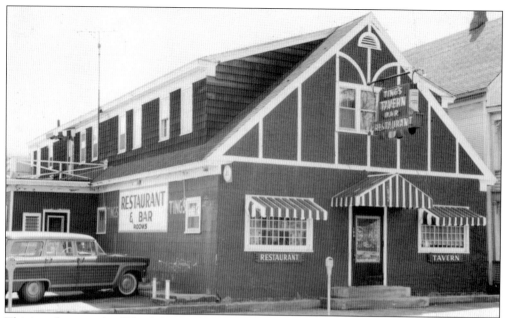

This is a photograph of Ting's Bar and Restaurant in the 1950s and 1960s. It was built on the site of the old Buck Block. Ting was the son of Fred Breyette, who was always in the food business. Fred used to deliver meat from Morrisonville, New York, before he had his own store. It was a special place for teens to hang out at its soda bar after school games and functions. Gloria Hart was the waitress and referee.

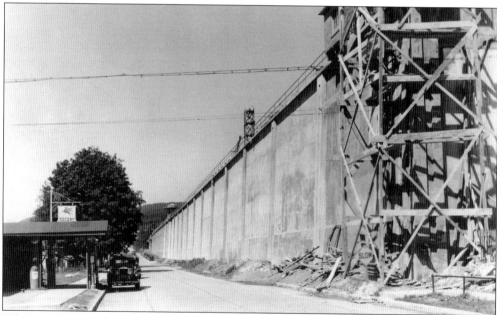

While on the subject of food, Pearl's Michigans cannot be overlooked. The house in the background past the gas station on the left was the home of Pearl Thompson. One could walk in the back door, go to the refrigerator for a drink, sit down at the kitchen table, and order a Michigan hot dog "wit" or "witout" onions. This photograph is undated, but the authors still remember Pearl, Rose, and Pikey.

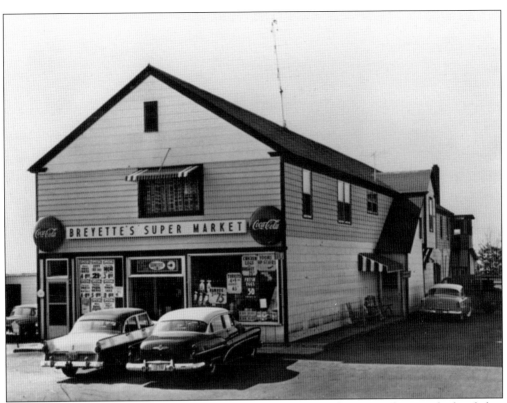

Donald Breyette, Ting's brother, had the big grocery store nearby. It was first run by his father Fred, and Donald continued the family business. He and his family lived upstairs. There was also a fire there—not quite as severe as the Buck Block fire, and the store was rebuilt.

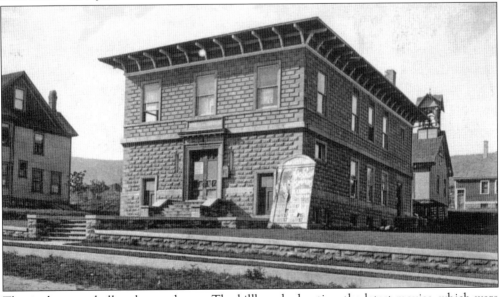

This is the town hall and opera house. The billboard advertises the latest movies, which were shown upstairs in the 1940s and 1950s. Ramp-like covered fire escapes were added in the 1950s. The old firehouse is visible behind the town hall.

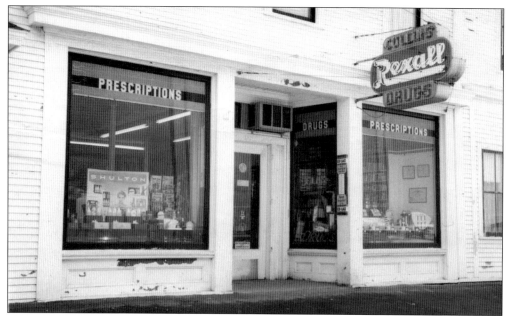

This is the well-known drugstore location on Cook Street. The pharmacies of W.J. Manion, Gilbert Collins, and Leo "Skip" Maggy were located there. Skip Maggy moved to the corner of Cook and Emmons Streets, where the first schoolhouse stood. He and his sons run a full-service operation there today.

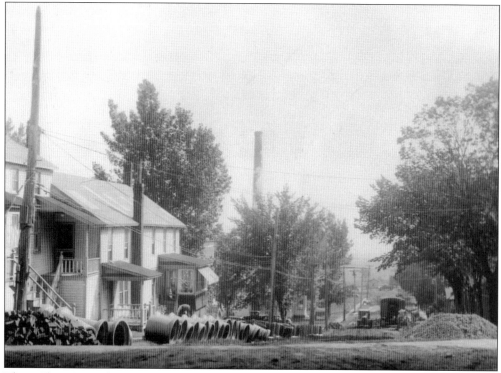

This is Flagg Street during the new sewer line installation, about 1935. The Beehive is on the left, with the residents' porches visible. On the right was Jennett's grocery location.

After the fire on the Buck Block in 1945, the mail was sorted at a storefront in the Palmer Block. This store would later be Jennett's grocery, run by Paul and Millie Jennett. Villagers picked up mail there until this post office on Emmons Street was ready in the late 1940s.

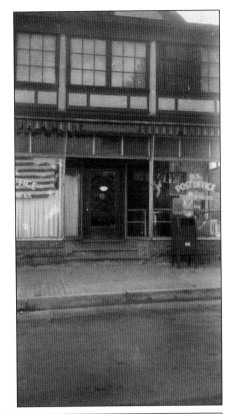

This is the Kennedy Hotel, across from the post office. As an Irish establishment, it was also known as the "Shebeen," a name for an illicit bar or club. The word derives from the Irish "sibin," meaning illicit whiskey. The wooden bar still survives at Chazy Lake, but the building does not.

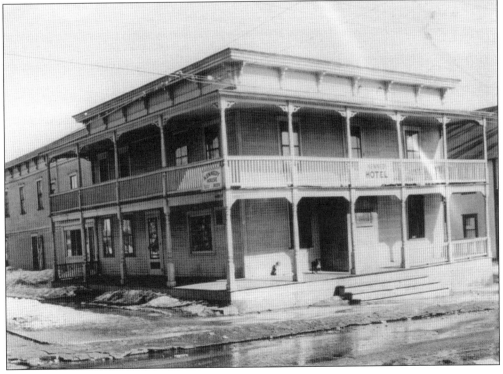

This is the Light House, which was built about 1895. The Van Gorder family were the first residents, followed by the Cosgrove family. Walter E. Light, father of coauthor Pete Light, was owner in the 20th century. It still stands, much improved, on Emmons Street, with Pete and his wife, Pat, in residence.

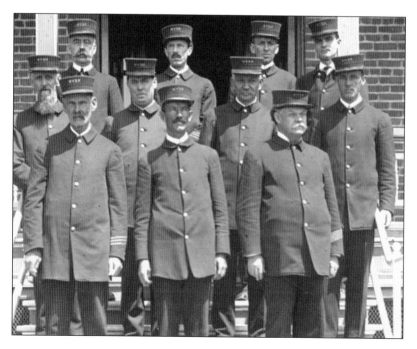

This c. 1912 photograph of guards includes, from left to right, (first row) Michael O'Neil, James Gorman, and Morgan Van Gorder; (second row) George Buck, Jeff Powers, William Mead, and Elmer Drollette; (third row) Michael Houlon, Louis Priest, Walter Haskel, and William Willett.

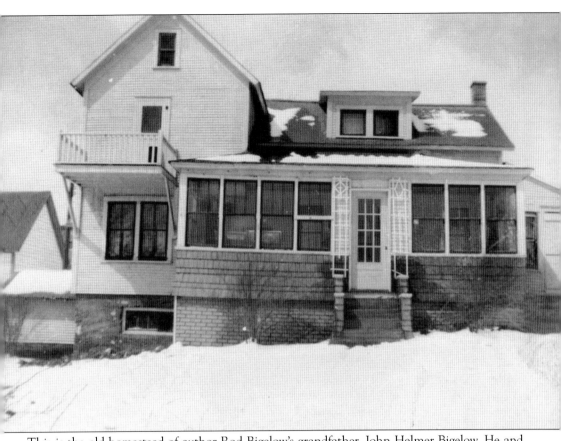

This is the old homestead of author Rod Bigelow's grandfather, John Helmer Bigelow. He and his wife, Pearl (Hoff), built this place in the early 1900s. The house was greatly improved over the years and still stands.

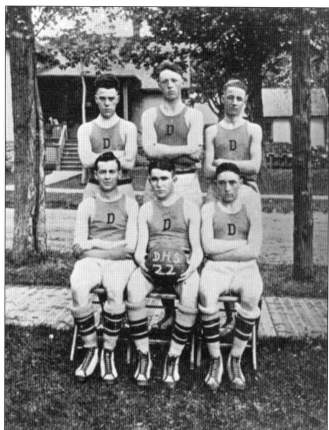

This is the 1922 Dannemora basketball team. The notes on back of the photograph identify Capt. Myron Cummings No. 4; Manager Harold Brennan; Hunt Signor; Harold Smith No. 2; and Alphonse Lafontaine No. 6. Alphonse sits at the front on the left. Many other team portraits can be found in the Dannemora Historical Society Museum and the Village Museum.

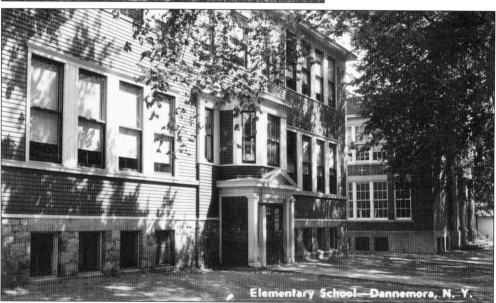

Pictured here are the elementary school on the left and the high school on the right. The photograph was taken from Flagg Street. The elementary school is gone, but the high school building, classrooms, and gym were preserved by Steve Coulon.

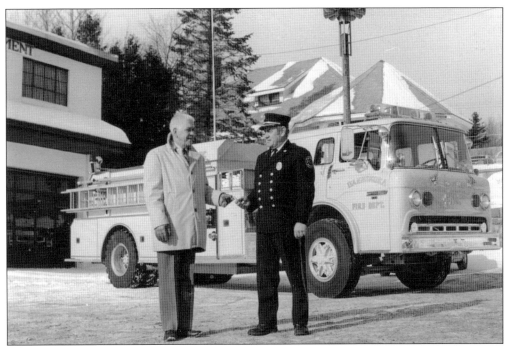

Mayor William E. "Bill" Donahue hands over the keys to a new fire truck to fire chief Robert Mullady. Bill Donahue was mayor of Dannemora from 1958 to 1983, the longest tenure for mayor of this village. He also held positions on the New York Conference of Mayors.

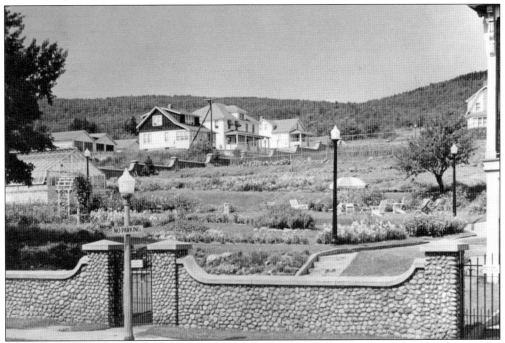

This is a view from the front of the warden's house. Homes along TB Hill are visible in the background. In a controversial decision, the state demolished the house in 1969 to make way for a new entrance gate. It remains one of the North Country's most impressive lost landmarks.

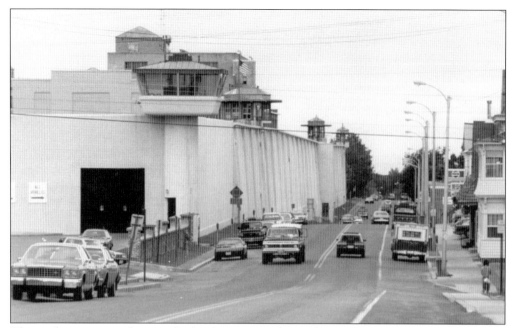

This is the new gate that was built after tearing down the warden's residence. The smooth finish on the prison wall was done in 1935. Many images of its construction and the other gates built are in the Village Museum. This is a modern photograph of Cook Street.

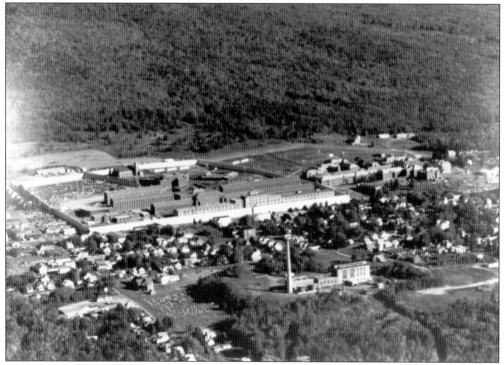

This is an overall view of Dannemora after 1969. The warden's house is gone, as well as elementary school and the Beehive. Also, the new smokestack at the powerhouse is visible. Residents still remember the demolition of the old one in the 1950s.

Three

CHAZY LAKE

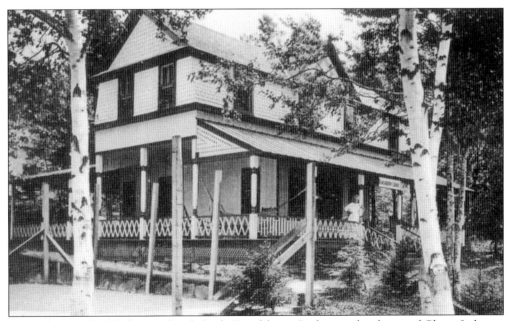

Around 1899, the Wightman family built Bunchberry Lodge on the shores of Chazy Lake on the pump house side. They recorded their visits with the many photographs that Chazy Lake historians acquired.

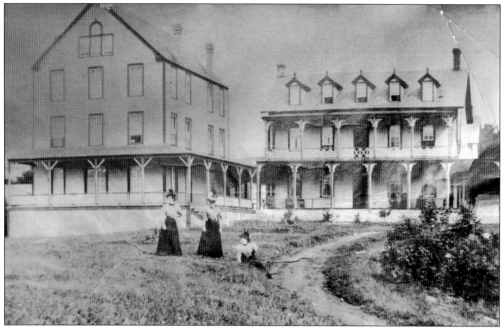

This is the Chazy Lake House Hotel. The original two-story structure was built in 1869. There was also a Fifield House mentioned on the lake, but the site is unknown. Both houses may have been the same hotel site.

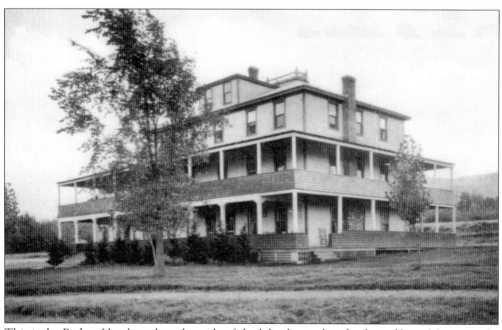

This is the Badger Hotel on the other side of the lake, located at the foot of Lyon Mountain. In June 1907, George S. Badger advertised his improved hotel in the *Plattsburgh Sentinel*. Also known as the Lake View House, it was just a short stroll or ride from the Chazy Lake Railroad Station.

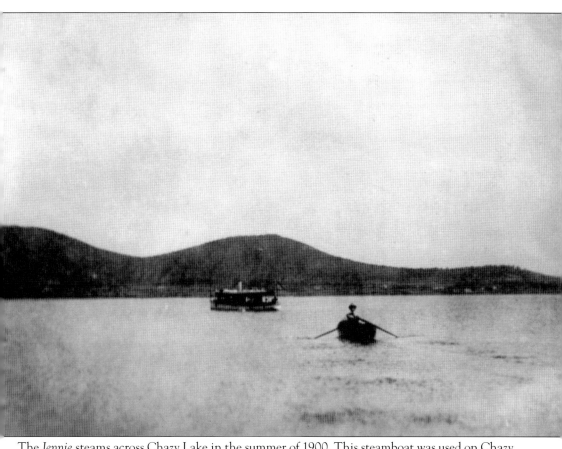

The *Jennie* steams across Chazy Lake in the summer of 1900. This steamboat was used on Chazy Lake to shuttle between the two hotels. A Wightman rowboat from Bunchberry Lodge is following in its wake. (Courtesy of Chazy Lake historians.)

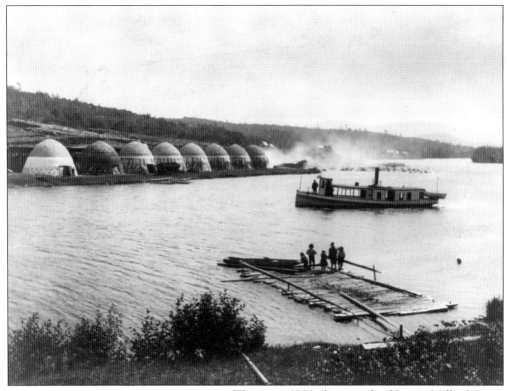

This is an 1880 photograph of *Jennie*. Millard S. Bellows, from Chateaugay Lake, built the *Jennie* around 1875. It was a clincher-built boat and could carry 25 passengers. Bellows ran the boat himself until the fall of 1881, when he sold the steamer; the new owner moved it to Chazy Lake. (Stoddard.)

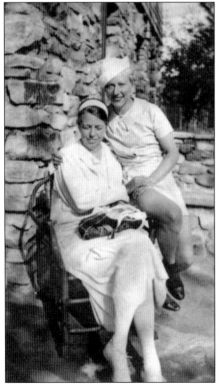

This is a photograph of Eleanor Roosevelt and friend Mayris "Tiny" Chaney at the Werrenrath "Camp" on Chazy Lake. Many more stories and pictures are to be found in *Chazy Lake: Facts, Fiction, and Folklore* by Chazy Lake historians. (Author's collection.)

Four

Lyon Mountain and Upper Chateaugay Lake

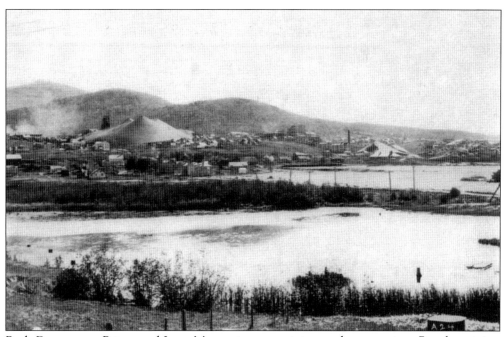

Both Dannemora Prison and Lyon Mountain were mining at the same time. But the mining in the Lyon Mountain area was growing, and the first shipment of ore by rail passed through Dannemora in 1879. The mining at the prison had stopped the year before.

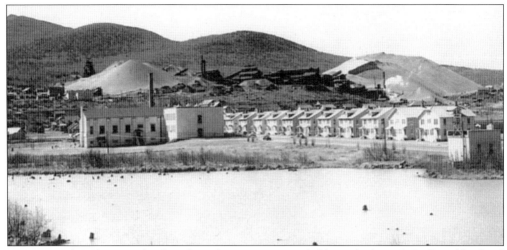

Here is another photograph taken from the same spot, probably in the late 1940s. Republic Steel was operating instead of Chateaugay Ore and Iron Company in that era. Note the high school. Lyon Mountain School was later merged with Ellenburg, and the high school was turned into minimum security for the prison system. It is now vacant.

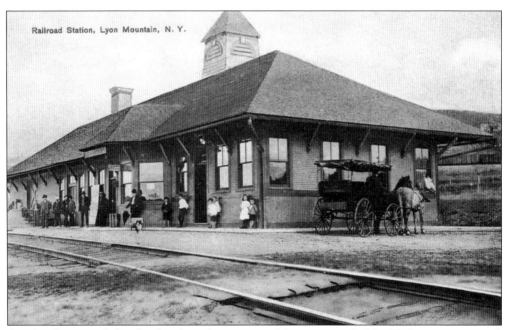

A railroad was needed to develop the rich resources of this property. In May 1879, it was organized, and the first regular train ran over the entire line later that year. This railroad station is now the home of the Friends of Lyon Mountain Mining and Railroad Museum.

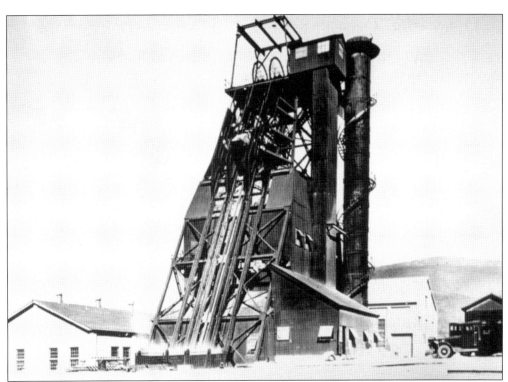

This photograph shows buildings and equipment of the Lyon Mountain mining operation. The head frame was used to lower and raise the miners in the "manskip" at a slope angle. The ore piles were not too tall in those days. (Courtesy of the Friends of Lyon Mountain Mining and Railroad Museum.)

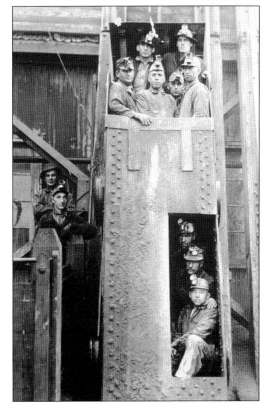

This is an iconic photograph of the manskip. It was the elevator of its day and carried the miners to their work. (Courtesy of the Friends of Lyon Mountain Mining and Railroad Museum.)

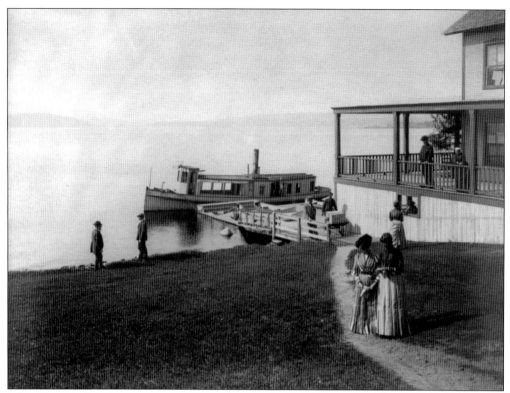

Like Chazy Lake, there were some great hotels along the Upper Chateaugay Lake. This is a Stoddard photograph taken around 1880. It was in his Adirondack collection and shows the steamboat *Jennie* in front of Ralph's and the Merrill House.

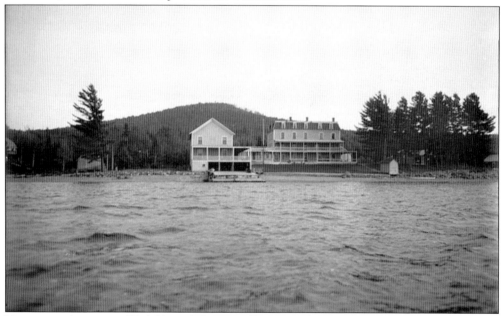

Here is another view of Ralph's and the Merrill House taken at around the same time. *Jennie* shuttled passengers between hotels on the lake, including the Owlyout Hotel. (Stoddard.)

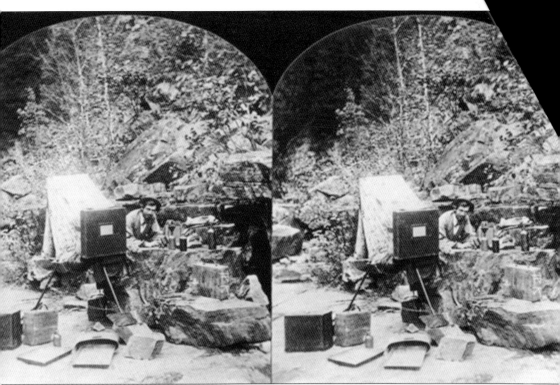

This Stoddard self portrait was taken with his stereo camera. When Stoddard visited Dannemora in the 1870s, he saw a prison on the side of a mountain, facing south, and the mountain rising higher behind the prison in bleak, rocky, rolling ledges. It was during the tenure of Gen. Stephen Moffitt (1873–1876) that Stoddard came to photograph Clinton Prison. In 1879, his photographs appeared in an issue of *The North Countryman* along with comments about prison life. It is believed these were the first photographs ever taken of Clinton Prison.

ϽVER THOUSANDS OF LOCAL HISTORY BOOKS
ΛTURING MILLIONS OF VINTAGE IMAGES

Arcadia Publishing, the leading local history publisher in the United States, is committed to making history accessible and meaningful through publishing books that celebrate and preserve the heritage of America's people and places.

Find more books like this at
www.arcadiapublishing.com

Search for your hometown history, your old stomping grounds, and even your favorite sports team.

Consistent with our mission to preserve history on a local level, this book was printed in South Carolina on American-made paper and manufactured entirely in the United States. Products carrying the accredited Forest Stewardship Council (FSC) label are printed on 100 percent FSC-certified paper.

MADE IN THE